kinship

kinship

Dorothy Moss and Leslie Ureña
with Robyn Asleson, Taína Caragol,
and Charlotte Ickes

National
Portrait
Gallery

HIRMER

This publication and the related exhibition have been made possible through the generous support of:

John and Louise Bryson

Frances Stevenson Tyler

The Haynes and Boone Foundation, Purvi and Bill Albers, Susan and David McCombs

Lyndon J. Barrois Sr. and Janine Sherman Barrois

Lisa Goodman and Josef Vascovitz

Additional support has been provided by the American Portrait Gala Endowment.

Contents

Foreword

A *rt is not only part of history—even a living history—it is part of and makes community, it is part of and makes family.*[1]

Many of us remember posing with family members for obligatory photographs taken during special occasions to honor our traditions. These moments create what Marianne Hirsch calls a generational transmission, but they yield selective memories and mark time in a way that may tell only a fraction of the story.[2] Documenting occasions such as weddings, birthdays, holidays, and funerals is part of how one memorializes an event and better understands oneself in relation to others, but family portraits also remind us of those who are missing, those who can no longer join us inside the frame.

Kinship considers the limitations of family portraits and allows for an expansive understanding of community and connection. Through a broader interpretation of our kin, the notion of the nuclear family is challenged in myriad ways. In this regard, kinship serves as a locus of intimacy and belonging and often becomes a counternarrative to feelings of isolation and displacement.

Just as history is not a grand narrative, neither are interpersonal connections. The eight artists featured in *Kinship* expose this idea, offering their perspectives on how memory, archive, and community form a symbiotic relationship between artists and subjects. Ideas of the nuclear family are deconstructed through works that bring historically marginalized individuals to the center. One photographer, who has documented a family over several years, reveals how he and his subjects have embraced each other in times of adversity. Another artist expands our understanding of kinship through a portrait of someone who has supported a community of Black artists for decades. Unexpected ties are formed through the harsh realities of navigating death and loss, and we see how challenging structural injustice can create a common language across generations and regions.

Art unites unlikely subjects. Through art, strangers can bond over a shared understanding of something; this is part of art's power. Art creates a kinship where ideas, experiences, and values can belie linear narratives. While some of these relationships may be tied to a familial bond, they are often made and cultivated by choice, not obligation.

As the world reels from the tremendous tragedy and impacts of the COVID-19 pandemic, it seems eerily prescient that this exhibition, which has been planned for several years, explores the notion of kinship. At one point, physically connecting with one's closest kin was a life-threatening proposition. Relationships had to find new and unusual ways to be sustained—or not. For a time, sharing a laugh or working together was either thwarted or mediated through a screen. And the loss of more than one million people in the United States to COVID-19 brought yet another meaning to kinship. Loss, memory, and grief formed a shared language. One can hope that some of these unwitting connections will serve as a bridge toward greater patience, understanding, and compassion for all.

A deep appreciation to curators Robyn Asleson, Taína Caragol, Charlotte Ickes, Dorothy Moss, and Leslie Ureña, who worked together under exceedingly difficult circumstances to develop this "Portraiture Now" exhibition. The project would not have been possible without the leadership of Kim Sajet, director of the National Portrait Gallery, and the generous support that the museum received from John and Louise Bryson; Frances Stevenson Tyler; The Haynes and Boone Foundation, Purvi and Bill Albers, Susan and David McCombs; Lyndon J. Barrois Sr. and Janine Sherman Barrois; and Lisa Goodman and Josef Vascovitz. Thanks, as well, to the American Portrait Gala Endowment.

Special gratitude to each artist represented in this show. Your work and creativity, especially during such trying times, has been an inspiration and helped us better understand the world and the special role each of us can play in making it a better place.

Rhea L. Combs,
Director of Curatorial Affairs
National Portrait Gallery

1 See Kellie Jones, "Art in the Family," introduction in *EyeMinded: Living and Writing Contemporary Art* (Durham, NC: Duke University Press, 2011), 1.

2 See Marianne Hirsch, *The Familial Gaze* (Hanover, NH: Dartmouth Press, 1999).

Portraiture Now

The National Portrait Gallery entered into the twenty-first century with a new vision. Over the past two decades, the museum has developed an impressive contemporary art collection, introduced robust programing, and published important scholarship on living artists. This work has transformed the Portrait Gallery into a place that both honors historical figures and responds to contemporary events from diverse perspectives.

From 1968, when the museum first opened to the public, to 2000, portraits could only enter the permanent collection after the sitter had died. The idea was that curators and historians should take their time to assess an individual's impact on history before acquiring a portrait of the person. This rule no longer applies. Whether through commissioning artworks for the collection or organizing exhibitions and programs, such as the IDENTIFY performance art series, Portrait Gallery curators have located and presented groundbreaking new work. Today, the museum reaches broader audiences than ever before, and we strive to ensure that everyone who walks through our doors will see their story represented. The "Portraiture Now" series has become a core component of the Portrait Gallery's contemporary initiatives, and *Kinship* came to fruition through this dynamic exhibition program. Launched in 2006, the series encourages audiences to consider the possibilities of contemporary portraiture by providing insights into new modes of thinking and artmaking.

There is always room for experimentation, and with each exhibition, there is a first. With the inclusion of work by Anna Tsouhlarakis, an artist of Creek, Navajo, and Greek heritage, this is the first exhibition of the series to include an Indigenous artist and to present performance art. All of the portrayals featured in *Kinship* illuminate how our personal relationships center us and color our life experiences. Today, more profoundly than ever, portraiture reveals its potential to promote empathy and equity in inventive—and poignant—ways.

Dorothy Moss

Past "Portraiture Now" exhibitions

Portraiture Now
July 1, 2006–April 29, 2007
William Beckman
Dawoud Bey
Nina Levy
Jason Salavon
Andres Serrano
Curated by CC, BBF, ACG, FG, TPH,
WWR, AS

Framing Memory
May 25, 2007–January 6, 2008
Alfredo Arreguin
Brett Cook
Kerry James Marshall
Tina Mion
Faith Ringgold
Curated by CC, BBF, ACG, FG, WWR, AS

RECOGNIZE! Hip-Hop and Contemporary Portraiture
February 8–October 26, 2008
Tim Conlon
Nikki Giovanni
Dave Hupp
Jefferson Pinder
David Scheinbaum
Shinique Smith
Kehinde Wiley
Curated by JB, BBF, FG

Feature Photography
November 26, 2008–September 27, 2009
Katy Grannan
Jocelyn Lee
Ryan McGinley
Steve Pyke
Martin Schoeller
Alec Soth
Curated by BBF, ACG, FG, WWR, AS

Communities
November 6, 2009–July 5, 2010
Rose Frantzen
Jim Torok
Rebecca Westcott
Curated by BBF, ACG, FG

Asian American Portraits of Encounter *
August 12, 2011–October 14, 2012
Zhang Chun Hong
CYJO (Cindy Hwang)
Hye Yeon Nam
Konrad Ng
Shizu Saldamando
Roger Shimomura
Satomi Shirai
Tam Tran
Curated by BBF, ACG, FG, LJ, RK, KN, WWR, AS, DW, in collaboration with the Smithsonian Asian Pacific American Program

Drawing on the Edge *
November 15, 2012–August 18, 2013
Mequitta Ahuja
Mary Borgman
Adam Chapman
Ben Durham
Till Freiwald
Rob Matthews
Curated by BBF, ACG, FG, DM, WWR, DW

Staging the Self *
August 22, 2014–April 12, 2015
David Antonio Cruz
Carlee Fernandez
María Martínez-Cañas
Rachelle Mozman
Karen Miranda Rivadeneira
Michael Vasquez
Curated by TC, RK, DM, DW

* traveled to other venues

The Face of Battle: Americans at War, 9/11 to Now
April 7, 2017–January 28, 2018
Ashley Gilbertson
Tim Hetherington
Louie Palu
Stacy Pearsall
Emily Prince
Vincent Valdez
Curated by TC, DM, AN, DW

Unseen: Our Past in a New Light, Ken Gonzales-Day and Titus Kaphar
March 23, 2018–January 6, 2019
Ken Gonzales-Day
Titus Kaphar
Curated by TC and AN

Kinship
October 28, 2022–January 7, 2024
Njideka Akunyili Crosby
Ruth Leonela Buentello
Jess T. Dugan
LaToya Ruby Frazier
Jessica Todd Harper
Thomas Holton
Sedrick Huckaby
Anna Tsouhlarakis
Curated by RA, TC, CI, DM, LU

Curators:
Robyn Asleson (RA)
Jobyl Boone (JB)
Taína Caragol (TC)
Carolyn Carr (CC)
Brandon Brame Fortune (BBF)
Anne Collins Goodyear (ACG)
Frank Goodyear (FG)
Charlotte Ickes (CI)
Lauren Johnson (LJ)
Rebecca Kasemeyer (RK)
Dorothy Moss (DM)
Asma Naeem (AN)
Konrad Ng (KN)
Tia Powell-Harris (TPH)
Wendy Wick Reaves (WWR)
Ann Shumard (AS)
Leslie Ureña (LU)
David Ward (DW)

Regarding Kinship

Dorothy Moss and Leslie Ureña
with Robyn Asleson, Taína Caragol, and Charlotte Ickes

Even by its simplest definitions, "kinship" is a multifaceted concept. In anthropology, the word is meant to encompass "relatedness or connection by blood or marriage or adoption." More broadly, it is defined as "a close connection marked by community of interests or similarity in nature or character."[1]

The decision to focus on kinship for this "Portraiture Now" exhibition followed numerous discussions regarding family in relation to contemporary art. As the project's curatorial team considered the theme, however, it became clear that the works we were selecting addressed more than the core genetic and legal definitions of "family."[2] A number of these projects reveal new, even surprising ways of understanding our close bonds with others—both people within and outside of family units.[3]

The theorist Tracy Rutler notes that "by decentering the experience of the nuclear family, we might be able to expand what we expect from kinship and intimacy."[4] Likewise, the artists in *Kinship* simultaneously center and decenter the nuclear family through their intimately expansive approaches to family and kin. Even when we consider those artists who cast their nuclear family as their subject, we can see their work forging connections among larger communities. It is, therefore, at the intersection of the nuclear family and the communal experience where these artists' projects are in dialogue, where our curatorial vision is rooted.

Kinship visualizes the complexities of interpersonal relationships with portrayals by Njideka Akunyili Crosby, Ruth Leonela Buentello, Jess T. Dugan, LaToya Ruby Frazier, Jessica Todd Harper, Thomas Holton, Sedrick Huckaby, and Anna Tsouhlarakis. Each artist joins this conversation under very different circumstances and offers a distinct interpretation of kinship, prompting us to reconsider how human beings relate to one another. Despite their varied geographies—with artists now based in California, Colorado, Illinois, Missouri, New York, Pennsylvania, and Texas—together, their works deepen our understanding of kinship, particularly how it involves ideas of intimacy, vulnerability, privacy, familiarity, and recognition. The passage of time is another important facet. Several artists here illuminate the ways in which relationships evolve and demonstrate how kinship does—and does not—endure. These artworks also highlight the crucial role that storytelling and memories have in fostering our kin-like relationships, particularly between different generations and between the living and the dead.

Jessica Todd Harper's meditative photographs rely on storytelling to draw us into an intergenerational world within the artist's family. Children, parents, siblings, and grandparents relate to one another in scenes that evoke a harmonious coexistence. In many of these idyllic images, however, an individual's abstracted expression or direct eye contact with the camera creates a sense of detachment, as in *The Dead Bird* (see p. 61; 2018).

1 Jessica Todd Harper
Marshall (Yellow Ball), 2011
Inkjet print
81.3 × 81.3 cm (32 × 32 in.)
Courtesy of the artist

In *Self-Portrait with Marshall* (see p. 64; 2008), radiant light transfigures a cluttered bathroom into a sacred space, emphasizing the profound bond between Harper and her newborn son. Yet even as she holds her baby close to her body, she appears psychologically removed, lost in her own thoughts. This self-portrait, like many of Harper's photographs, underscores the private worlds that separate us

from one another, even from those whom we consider kin. As Marshall grows more independent, he, too, slips into private reveries, as we see in *Marshall* (*Yellow Ball*) (fig. 1) and *Comics* (see p. 67; 2020). Despite the strong sense of physical and emotional belonging in Harper's photographs of family life, there is also a persistent quality of isolated interiority. "Trying to access the inner life of children, all of us have this part of our souls that's not really touched by the outside world, that's eternal, and focusing on that can be therapeutic in terms of navigating the difficulties of human interaction," observes Harper.[5]

Photographer Jess T. Dugan also focuses on the mysterious beauty found in quiet, intimate moments at home. Dugan spent their childhood in Little Rock, Arkansas, where they defied the social conventions associated with young girls but, at thirteen, moved with their mother to Cambridge, Massachusetts. There, while living in a more progressive and accepting atmosphere, Dugan came out as gay and found community and kinship, particularly with those around them who identified as queer and gender expansive. Their ongoing series *Family Pictures*, begun in 2012, offers a view into their identity as a queer person and their relationships with their immediate family. The photographs in *Kinship* include portraits of Dugan with their spouse, Vanessa; their child, Elinor; and their mother, Diana. As the diminutive Elinor grows throughout the series, Dugan becomes more attuned to simultaneously identifying as both child and parent, and their camera begins to capture how the family dynamics shift over time, between generations.

This is most profoundly evident in *Self-portrait with mom* (*bed*) (fig. 2), where Dugan appears outstretched on the bed with their head propped up and leaning into their mother's lap. Sitting with her legs crossed, Diana protectively and reassuringly rests her right hand on her grown child's shoulder. Although Dugan is an adult, the mother-child dynamic remains strong. The motherly expression is a recognizable one of care, concern, and love.

"For me, the process of photographing, the way that I work, is so slow and collaborative, it functions as this way to carve out a special time and space with someone," notes Dugan. "I think of that especially with the pictures of me and my mom. There's a way in which this allows us to relate on a deeper level."[6] For Dugan, kinship is not only an abstract concept but something at the core of their practice.

Kinship is likewise central to Ruth Leonela Buentello's work. Combining materials that "come from . . . home," such as ribbons and cloth, she focuses on the spaces of her family's life, both physical and emotional.[7] In *Under the Mexican Colchas* (fig. 3), for example, we find a discomforting scene of the intimate space of her parents' bedroom. A dab of paint covers her reclining mother's lips almost like duct tape, effectively silencing her. The father's assertive presence in the foreground renders the view all the more unsettling, with their uneven gender dynamics also echoed in the lion *colcha* above the headboard. Yet, though Buentello's artworks visualize the tension and rifts caused by widely divergent life experiences across generations, they also convey love and union.

As a first-generation Mexican American, Buentello explores the cultural and generational gaps between herself and her parents,

2 Jess T. Dugan
Self-portrait with
mom (bed), 2020
from "Family Pictures"
Inkjet print
76.2 × 101.6 cm
(30 × 40 in.)
Courtesy of the artist

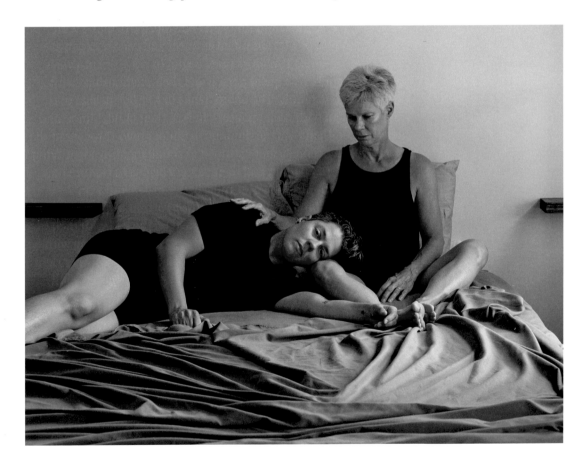

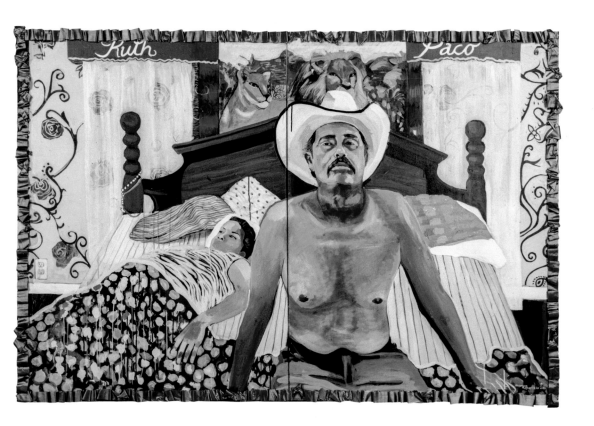

3 Ruth Leonela Buentello
Under the Mexican Colchas, 2012
Acrylic on canvases with fabric
121.9 × 152.4 cm (48 × 60 in.)
Courtesy of the artist

siblings, nieces, and grandparents in her large-scale yet intimate portraits. She probes the oppressive culture of patriarchy; reminisces about the punitive ways in which she was disciplined as a child; and reflects on the pressures of acculturation that her nieces face in a society that devalues brownness, indigeneity, and immigrant backgrounds. Buentello "[tries] to fill in the gaps" of communication and emotions that are absent from her source photographs.[8]

Entender de dónde nace tu manera de ser (Understanding where your selfhood comes from) (see p. 36; 2020), for instance, shows the artist's mother in three poses, all rendered from photographs Buentello took during a family outing. As her mom's face multiplies across the composition, so do her expressions of "laughter, anger, and pride," which, Buentello notes, are meant to suggest her "complexity as an immigrant woman [and] as my mother."[9] All the while, a small child demands attention, and, in one of the scenes layered within the different moments Buentello depicts, the child is in turn reprimanded through a firm grip of her arm. Buentello places her

grandmother's face within the flower-filled background as a means to both honor her and remind us of an earlier generation's child-rearing habits. The ruffled border renders the painting a three-dimensional object and connects to the family's domestic space. Installed against floral wallpaper, the materials in the painting bring us further into Buentello's multi-generational world.

Njideka Akunyili Crosby, who immigrated to the United States from Nigeria in 1999, selects images from her archive of family photos, newspapers, magazines, and books, then incorporates them into mixed-media artworks. Through a combination of painting, collage, photographic transfers, and drawing, she engulfs viewers in diasporic lives.[10] Her reliance on personal photographs calls to mind the words of Marianne Hirsch, who notes that for "lives shaped by exile, emigration, and relocation, . . . where relatives are dispersed and relationships shattered, photographs provide even more than usual some illusion of continuity over time and space."[11]

The lively and stylish boy of "The Beautyful Ones" Series #2a (see p. 31; 2016) represents Akunyili Crosby's brother, whose appearance here is based on one of the artist's family photographs from around 1988 (see p. 29). Not all of the works by Akunyili Crosby in Kinship, however, portray people related to her by blood or by law. "The Beautyful Ones" Series #3 (see p. 30; 2014), for instance, depicts two girls whom she encountered while at a friend's home in Nigeria. Their dresses reminded the artist of her own childhood, and she recalls having "a feeling of I know this" upon seeing the two of them. The hair of the girl at right evoked memories of her own childhood hairstyle.[12]

Akunyili Crosby has extended this sense of "knowing this," a sense of kinship, in other portraits as well, notably Thelma Golden (fig. 4). Golden, the director and chief curator of the Studio Museum in Harlem, has been a key figure in Akunyili Crosby's development. In fact, it was at the Studio Museum, during her time in the museum's acclaimed residency program (2011–12), that Akunyili Crosby challenged herself to make portraits and come to terms with painting the face.[13] Thelma Golden signals an important transition in Akunyili Crosby's artistic practice. In this layered portrayal, made in 2013, not only do we see Golden's face in frontal view, but we also sense the relationship between her and the artist, one built on mutual respect and admiration. The images that form Golden's dress and cover a large part of the background encapsulate important moments in

4 Njideka Akunyili Crosby
Thelma Golden, 2013
Acrylic, transfers, and colored pencil on paper
132.1 × 109.2 cm
(52 × 43 in.)
National Portrait Gallery, Smithsonian Institution

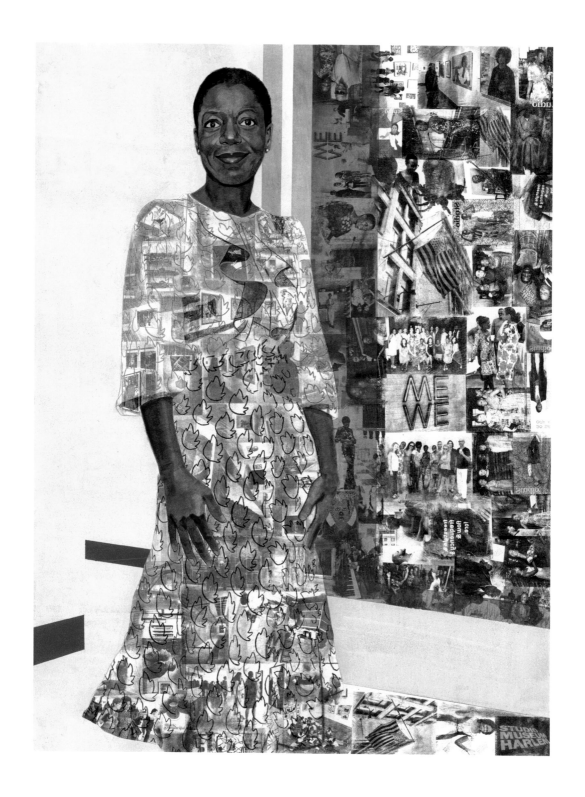

Golden's career, paying tribute to the museum she has stewarded since 2005 and signifying her influence over time.

Thomas Holton's strategy of documenting a subject over time is one that photo historian Bonnie Yochelson likens to the work of other photographers, such as Nicholas Nixon (b. 1947) and Milton Rogovin (1909–2001), who both spent decades capturing changes in relationships and the wear of time in the faces of their sitters. Holton's series *The Lams of Ludlow Street* relates to Nixon's and Rogovin's series in that it too evokes the passage of time and the materiality of the photograph as object, but his collaboration with the Lam family diverges from those other series because his longing for kinship pushed his work in a new direction, one straddling street photography and portraiture (fig. 5).[14]

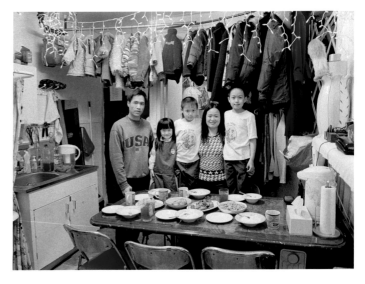

5 Thomas Holton
Family Portrait, 2004
from "The Lams of Ludlow Street"
Inkjet print
33 × 50.8 cm
(13 × 20 in.)
Courtesy of the artist

Holton's notion of kinship developed through a process of searching for a connection to and understanding of his Chinese heritage. Growing up in New York, he identified more with his white father than his Chinese mother and grandparents. His first encounter with the Lam family in New York's Chinatown offered him an opportunity to experience a life that might have been his own, one that felt both deeply familiar and foreign. "My mom's from China, but my dad's from right here in New York. And through exploring the streets of Chinatown, realizing that that wasn't nearly enough, I eventually got behind closed doors, and luckily met this family eighteen years ago. I'm still photographing them," he said.[15] As Holton's relationship with the Lams developed, his dream of becoming a travel photographer, like his father, soon gave way to a new purpose—understanding the place of Chinatown and ultimately connecting more closely with his heritage.

Even though Holton's maternal grandparents immigrated to the United States and moved to New York City's Chinatown when Holton was around four years old, he could not speak Mandarin,

and the communication gap hindered their closeness. He attended schools where he was one of the few Asian American students and identified more with his white friends than his other peers. Later in his adult life, this sense of disconnect from his Chinese heritage is what led him to the Lam family. He met them in 2003 while taking photographs for the University Settlement, an organization that has provided support for immigrants on the Lower East Side since the late nineteenth century. The Lams immediately opened their home to Holton and offered him a kinship that he realized he had been searching for his entire life.

LaToya Ruby Frazier similarly found kinship in a community, though it was far from her hometown of Braddock, Pennsylvania. Working in the tradition of the photographer Gordon Parks (1912–2006), whose in-depth exploration and study of his subjects evince the complexity of their situations, she began her survey *Flint Is Family In Three Acts* in 2016.[16] Having accepted a commission by *Elle* magazine for a story about the Flint Water Crisis, Frazier embedded herself in Flint, Michigan, with the idea of looking at the lives of three generations of women. She soon met Shea Cobb and Amber Hasan—two artists, activists, and poets—and traveled with them throughout the city, often following Cobb as she drove a school bus. The three of them bonded, forging deep personal connections. Their kinship is based, in part, on the shared experience of having survived a crisis.[17]

In each of the survey's photographs, a selection of which are presented here, Frazier compellingly makes visible a community's struggles and perseverance through her collaborative portraits of the Cobb family. She trained her lens on Shea Cobb; Cobb's daughter, Zion; Cobb's mother, Ms. Reneé; and their friends and relatives as they found ways to grapple with the economic, psychological, and physical effects of the crisis. Frazier recounts a pivotal moment when she visited Zion's school and felt "rocked . . . to the core to see that in America, we can go

6 LaToya Ruby Frazier
Shea Brushing Zion's Teeth with Bottled Water in Her Bathroom, Flint, Michigan, 2016–17
from "Flint Is Family In Three Acts"
Gelatin silver print
61 × 50.8 cm (24 × 20 in.)
Collection of Priscilla Vail Caldwell

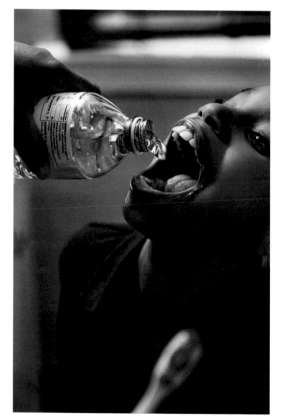

from fountains that say 'Whites' or 'Blacks only,' to today seeing fountains that say 'Contaminated water. Do not drink.'"[18]

Forced to protect themselves and one another from the contaminated waters of the Flint River, we see the family tending to such daily routines as brushing their teeth with bottled water (fig. 6) and also continuing to live and celebrate, as in *Shea Cobb with Her Mother, Ms. Reneé, and Her Daughter, Zion, at Nephratiti's Wedding Reception, Standing Outside the Social Network Banquet Hall, Flint, Michigan* (see p. 54; 2016–17). At the end of the first act of the photographic essay, Cobb leaves Flint in search of clean water. She and Zion travel to Mississippi, where Cobb's father owns land, water, and horses.[19] In *Shea and Her Daughter, Zion, Sipping Water from Their Freshwater Spring, Newtown, Mississippi* (see p. 56; 2017–19), we see them kneeling down and cupping water from a spring that has gathered in a trench made by Shea and her father. The family will have direct access to water, a source of their own, in a place where they hold agency over their living conditions.

Community also lies at the core of Sedrick Huckaby's paintings and sculptures. His family members, including his wife, artist Letitia Huckaby, children (both living and unborn), grandmother, and great-grandmother populate his works in portraits that represent the connections between individuals and their communities. The funerary T-shirts, for instance, allude to practices in the Black community of remembering family, friends, and neighbors who have passed away. By wearing their portraits, loved ones enact or embody the memorial (fig. 7).

With critical discussions about monuments circulating widely in the wake of racial unrest following the murder of George Floyd (1973–2020), Huckaby's incorporation of memorials into his own work resonates with larger dialogues among communities across the United States and the world regarding who deserves to be

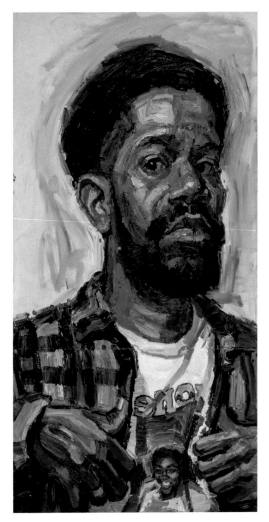

7 Sedrick Huckaby
Gone but Not Forgotten:
Sha Sha, 2017
Oil on canvas on panel
182.9 × 91.4 cm
(72 × 36 in.)
Jesuit Dallas Museum,
Dallas, Texas

remembered and how communities might best honor histories of loss due to violence and inequity. Huckaby's figures bring memorials and memorializing to life through the vibrancy of the sculpted forms, text, and colors he incorporates into his work. His use of newsprint adds another dimension of time and context to the portraits—an aspect that relates to the newspaper and magazine collages of Akunyili Crosby's work. Through installations that combine sculpture and painting, Huckaby collapses time and activates the universal experience of grief and the deepened sense of closeness we feel with loved ones who have passed away.

Anna Tsouhlarakis focuses on Indigenous women and girls who have been missing or murdered in *Portrait of an Indigenous Womxn [Removed]*, which is presented in *Kinship* as both a sculpture and a performance (fig. 8). Drawing attention to individual stories, including that of Kaysera Stops Pretty Places (2001–2019), while considering the violence impacting Native communities, Tsouhlarakis highlights the shared experience of trauma that has befallen them and responds to the silencing of their truths. As Tsouhlarakis moves through the Portrait Gallery's space, the beating of a hand drum calls attention to and honors the

8 Anna Tsouhlarakis
Portrait of an Indigenous Womxn [Removed], 2021
Exhibition copy of object for performance in 2023
30.5 × 35.6 cm (12 × 14 in.)
Courtesy of the artist

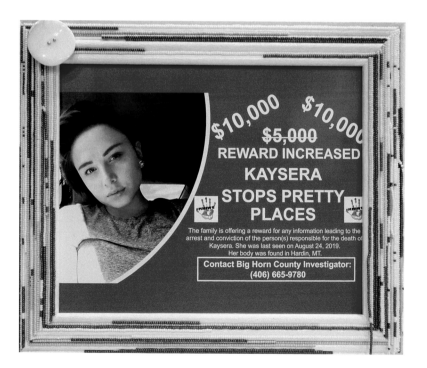

women and girls whose lives have been silenced. Tsouhlarakis stands with her Indigenous kin, mourns with them, and honors their meaningful lives. Her performance symbolically and literally calls us to see missing and murdered women and girls as daughters, sisters, and mothers.

Tsouhlarakis and the other artists represented in this volume remind us of our shared humanity. Through the lens of *Kinship*, we begin to understand how our most intimate relationships can illuminate our understanding of, and bring us closer to, those whose lives might at first appear divergent from our own. When we started working on this project, we could not have predicted that its core concepts would be tested on such a worldwide scale. The separation and overwhelming loss brought about by the COVID-19 pandemic have deepened the resonance of the exhibition's themes. When our daily routines came to a halt and our physical interactions were replaced by virtual forms of connection, we nonetheless continued to seek emotional closeness. These works by Akunyili Crosby, Buentello, Dugan, Frazier, Harper, Holton, Huckaby, and Tsouhlarakis, made before or during the pandemic, reveal the complexities of kinship, all the while sharing with us the bonds between and among artists and subjects. And, with the pandemic still affecting the lives of many and wars displacing millions from their homes, this profound longing for—and appreciation of—kinship remains.

1 See "Word of the Day: kinship," *New York Times*, May 18, 2021, which published these definitions from vocabulary.com.

2 Per the Health Resources and Services Administration of the U.S. government, "A family is a group of two or more persons related by birth, marriage, or adoption who live together; all such related persons are considered as members of one family." See "Definition of Family," under "Hill-Burton Free and Reduced-Cost Health Care," www.hrsa.gov/get-health-care/affordable/hill-burton/family.html.

3 For a recent article discussing the changes in family structures, see David Brooks, "The Nuclear Family Was a Mistake," *The Atlantic*, March 2020; the atlantic.com.

4 See Tracy Rutler, "What's Blood Got to Do with It? Reimagining Kinship in the Age of Enlightenment," Voltaire Foundation Blog, November 25, 2021. voltairefoundation. wordpress.com.

5 Harper quoted in unedited transcript for "Kinship: In Conversation" (internal document, p. 25). Interview held on November 10, 2021.

6 See "Kinship: In Conversation," pp. 96–97 in this volume, for related comments made by Dugan and other participating artists.

7 Ruth Leonela Buentello, quoted in "Face to Face: Kinship, A Conversation with Ruth Leonela Buentello and Sedrick Huckaby," conducted by the National Portrait Gallery on September 23, 2021 (internal recording).

8 See Buentello quoted in "Kinship: In Conversation," p. 105 in this volume.

9 Buentello quoted in "Face to Face," September 23, 2021.

10 More recently, for *"The Beautyful Ones" Series*, Akunyili Crosby has expanded her photographic archive to encompass the families of others. She and her siblings have asked friends for their family photographs, and those documents are slowly becoming part of her work. See Njideka Akunyili Crosby, "at home: Artists in Conversation | Njideka Akunyili Crosby," Yale Center for British Art, June 16, 2021, youtube.com (esp. 14:41 min.).

11 Cited in Justin Carville and Sigrid Lien, "Contact Zones: Photography, Migration, and the United States," in *Contact Zones: Photography, Migration, and Cultural Encounters in the United States*, eds. Justin Carville and Sigrid Lien (Leuven: Leuven University Press, 2021), 15, from Marianne Hirsch, *Family Frames: Photography, Narrative and Postmemory* (Cambridge, MA: Harvard University Press, 1997), ix.

12 See Cheryl Brutvan, "Interview with Njideka Akunyili Crosby," in *Njideka Akunyili Crosby: I Refuse to Be Invisible*, ed. Cheryl Brutvan (West Palm Beach, FL: Norton Museum of Art, 2016), 23–24. On the hairstyle affinity, see also Akunyili Crosby, "at home: Artists in Conversation | Njideka Akunyili Crosby" (esp. 17:20 min.).

13 See Akunyili Crosby, "at home: Artists in Conversation | Njideka Akunyili Crosby" (esp. 6:40 min.).

14 See Bonnie Yochelson, "Family Portrait," in Thomas Holton, Charles Traub, and Bonnie Yochelson, *The Lams of Ludlow Street* (Heidelberg: Kehrer Verlag, 2016 [2015]), n.p.

15 See unedited transcript for "Kinship: In Conversation" (internal document, p. 7). Interview held on November 9, 2021.

16 Here, we are thinking specifically of Gordon Parks's engagement with Ella Watson during his time working for the Farm Security Administration. See, for example, his photograph *Washington, D.C. Mrs. Ella Watson, A Government Charwoman, with Three Grandchildren and Her Adopted Daughter*, August 1942 (loc.gov/item/2004672676). See Philip Brookman, "Gordon Parks: The Sphere of Conscious History," in *Gordon Parks: The New Tide, Early Work 1940–1950*, ed. Philip Brookman (Washington, D.C.: National Gallery of Art, 2018), 219–57, esp. plate 37.

17 See LaToya Ruby Frazier, "Artist's Statement," p. 49 in this volume.

18 See LaToya Ruby Frazier, "A Creative Solution for the Water Crisis in Flint, Michigan," TED, September 2019, ted.com (esp. 1:19 min.).

19 Shea Cobb's father, Douglas R. Smiley, owns around 90 acres of land, which he plans to pass on to Shea and her family.

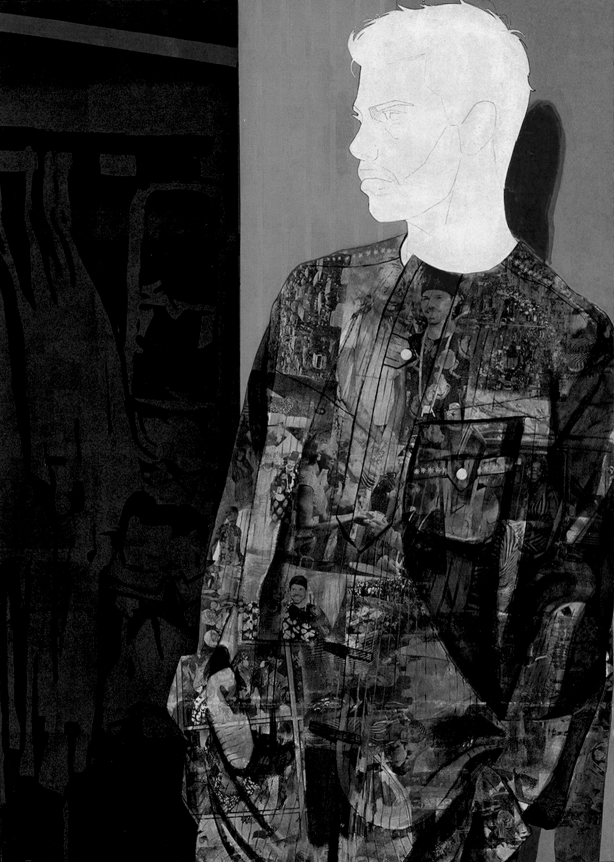

Njideka Akunyili Crosby

born 1983, Enugu, Nigeria
based in Los Angeles, California

My works featured in this exhibition attest to the multifaceted nature of kinship. About ten years ago, I was home for the holidays and saw the two girls in *"The Beautyful Ones" Series #3*. Beaming in their new Christmas outfits, they reminded me of the pride my siblings and I felt as kids when, on Christmas Day and the day after, we would walk around the neighborhood showing off our *akwa ekeresimesi*. For the composition, I situated the girls in an invented interior and added details emblematic of where and when I grew up. The screen walls reference our house in Enugu, while the terrazzo floors take me back to our village house in Agulu. The jumping horse Vlisco fabric was popular among Igbo women in the 1980s and 1990s. To further emphasize the kinship that I felt with these girls, I transferred images of my siblings and me onto the piece.

"The Beautyful Ones" Series #2a depicts my older brother as a child. Along with several of the transferred images, his outfit and pose imply the heavy influences that both American pop music and Nigerian military rule had on Nigeria. These cultural and political aftereffects of (among other things) colonial occupation are likely familiar not only to Nigerians of my generation but also to anyone who has lived in a post-colonial setting.

My partner posed for *Nkem* wearing a senator suit we had made for our traditional wedding in Nigeria. This style of suit marries together Nigerian silhouettes and fabrics typical of European formal wear: the suit combines cuts from traditional Igbo and Niger Delta garments, and the material is worsted wool. Though its origins are in southeastern Nigeria, the senator suit has, over the past two decades, been adopted by the over two hundred ethnicities throughout the country.

For the transferred images in the portrait of Thelma Golden, I selected photos that provide a glimpse into the dynamic community she has cultivated around the hub of Black art that is the Studio Museum in Harlem. As an artist in residence at the Studio Museum, I developed strong bonds with Thelma and many others, and these relationships are still very dear to me.

All of these works touch upon the various ways we become kin.

Njideka Akunyili Crosby brings viewers into the spaces that she inhabits, both physically and otherwise. After moving from Nigeria to the United States to study in 1999, the artist remembers it took about five years for the pangs of homesickness to manifest themselves. That was when she "started collecting pictures."[1] On trips back to Nigeria, Akunyili Crosby gathered the few family photographs that existed, along with political posters and magazines, which she then began incorporating into her art.[2] Works such as *Nkem* (2012) use some of Akunyili Crosby's carefully selected imagery to immerse us in narratives of an existence in a space that is replete with existing memories and the creation of new ones.

This composition draws viewers into a domestic setting. At left, an open closet reveals neatly hanging shirts and other attire in a treatment reminiscent of an X-ray. At right, we encounter a male figure leaning against a wall. Fine pencil marks outline the man's eyes, lips, and ears—just enough to reveal his identity as Akunyili Crosby's spouse, the artist Justin Crosby. The couple met in college, and Akunyili Crosby was keenly aware of how their relationship (Crosby is a white American) could be perceived as if she had "turned her back on her people."[3] *Nkem* and other paintings by Akunyili Crosby, however, firmly establish him as part of her world, as signaled here by the work's very title.[4] "Nkem" is both a shortened form of the middle name of the artist's mother, Dora Nkemdilim Akunyili, and an Igbo term of endearment meaning "mine" or "my own."[5]

Compositionally, Akunyili Crosby powerfully situates her husband as part of various times and places, both real and imagined, by rendering him visible through photographic transfers. While a detailed portrayal of his face may be absent, his likeness and those of others appear on the suit.[6] As we move down the figure, we find him alongside Akunyili Crosby, in photographs of family events in Nigeria. Evoking the abundance of images "all over the floor and the wall" of the artist's studio, he stands

Source photographs for *Nkem*, Njideka Akunyili Crosby and Justin Crosby's wedding day, 2009
Courtesy of the artist

»
Njideka Akunyili Crosby
Nkem, 2012
Acrylic and transfers on paper
192.9 × 129.5 cm
(75 $^{15}/_{16}$ × 51 in.)
Rubell Museum

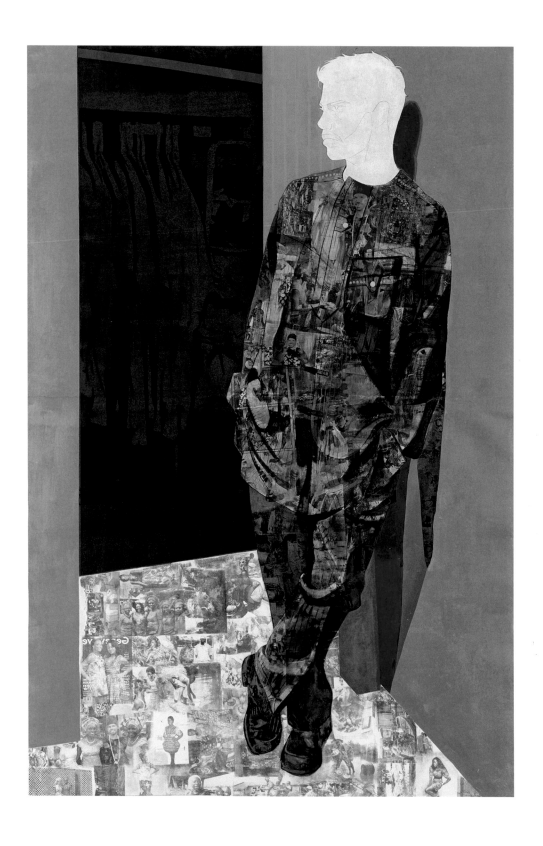

on photographic transfers.[7] As Akunyili Crosby carefully sketches out her compositions, she must first decide where each transfer will go. Working with scanned copies of family photographs, magazines, and other images, she then applies the pictures directly onto raw paper through the acetone transfer process.[8] Here, the multilayered approach takes on a new valence as the transferred areas serve as the very ground Justin Crosby stands on. The images, and the histories that they connote, also envelop him as they cover his senator suit and shoes.

Though highly personal, Akunyili Crosby's works are not solely self-referential to her life and that of her family. Rather, she establishes a level of kinship with viewers while revealing the hybrid spaces—whether physical or mental—of diasporic life inhabited by many others.[9] Leslie Ureña

»
Njideka Akunyili Crosby incorporates family photographs, such as those shown here, into her work. For "The Beautyful Ones" Series #2a (p. 31), she looked at her brother's likeness in the middle picture.

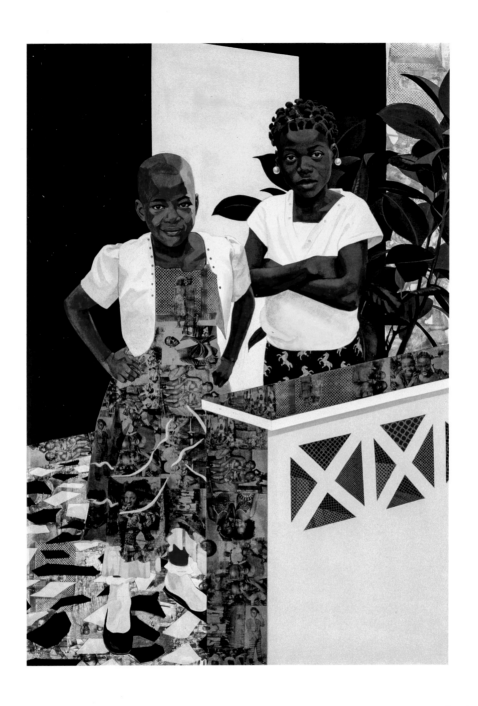

Njideka Akunyili Crosby
"The Beautyful Ones" Series #3, 2014
Acrylic, colored pencil, collage,
charcoal, and transfers on paper
155.6 × 106.7 cm (61 ¼ × 42 in.)
Collection of Caren Golden and
Peter Herzberg

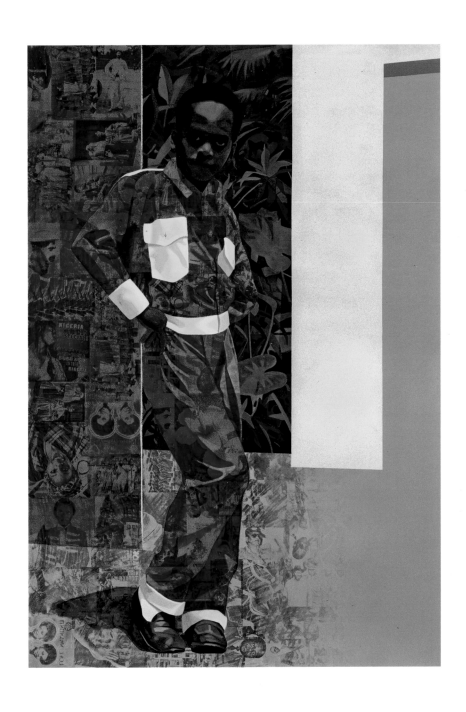

Njideka Akunyili Crosby
"The Beautyful Ones" Series #2a, 2016
Acrylic, transfers, and colored
pencil on paper
155.6 × 106.7 cm (61 ¼ × 42 in.)
Collection of Charles Gaines

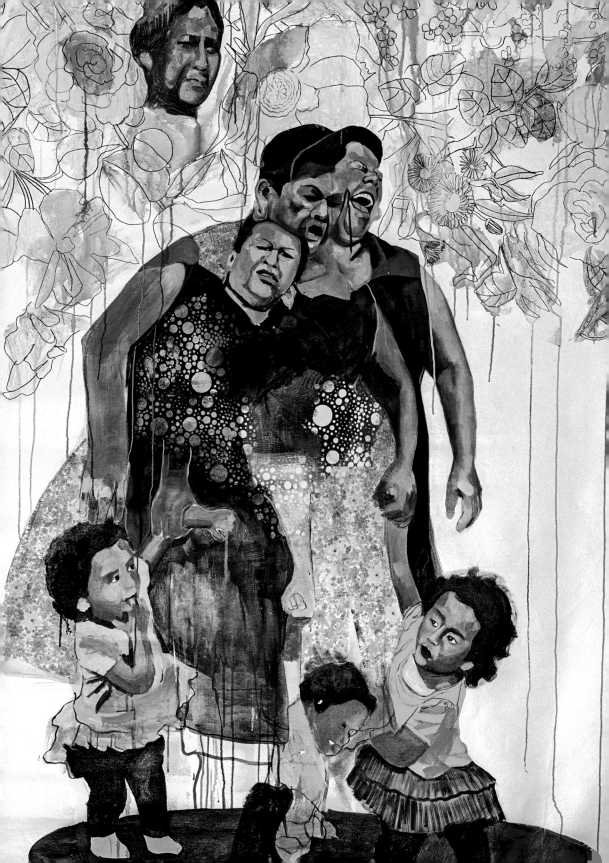

Ruth Leonela Buentello

born 1984, San Antonio, Texas
based in San Antonio, Texas

Kinship, like family, is forever—in the good, the bad, and the spaces in between. Through my paintings, I share layered, complex narratives of my family, our emotions, and our exchanges. My work attempts to interpret the silences we experience with one other, those moments that feel too difficult to discuss. The spaces my family inhabits, whether emotional or physical, provide the backdrop for kinship to unfold.

My process begins with a memory extracted from an everyday experience. I then create a composite using family snapshots and my memory of the event. I focus on expressions and the body as I contemplate these silent narratives. I am very interested in non-traditional portraiture and the stories our bodies carry.

Memory is an integral part of my work, and the objects and materials within the home serve an important function. For me, fabric evokes a tangible memory. *Telas* (fabrics) have played a significant role in my family for generations. My mami learned to sew from her great-grandmother and she from her great-grandfather. For each artwork, I take careful consideration in choosing the fabric patterns that generate specific memories. I add pieces of found fabrics that remind me of my loved ones. The creation of these works allows me to process the dysfunction in my family and helps me find gratitude in those closest relationships. I am reminded that this is my story to tell, and kinship is a perpetual well of inspiration for my artistic process.

When asked to picture a painting of a woman wearing a Mexican *huipil* and engulfed by nature, one of Frida Kahlo's psychological self-portraits may spring to mind. The Chicana artist Ruth Leonela Buentello acknowledges Kahlo's influence on her practice: "As much as I try not to imitate her work, Frida has slipped into my subconscious. Her over-commercialization turned me away from connecting with her work, but we both work from a place of pain and reflection. Frida is my 'comadre' in the studio."[1]

Nopalera, which explores Buentello's interiority and cultural identity, conjures the compositional structure of Kahlo's *Self-Portrait with Thorn Necklace and Hummingbird*.

Buentello's centrality in her self-portrait is rivaled only by the patch of prickly pear cacti where she stands. In a position of utter vulnerability, she puts her hands behind her head. Perhaps she is trying to avoid the scratches and punctures of the cacti thorns, or maybe this is her gesture of surrender. Broad pink brushstrokes conceal Buentello's mouth and the embroidered design of her blouse. These erasures silence her voice and emotions. With a downward gaze and red drips falling from the prickly pears, the artist—like Kahlo—uses art to convey her personal pain.

By titling her portrait *Nopalera* and suppressing her mouth and chest, Buentello evokes the tension of being a bicultural American. The word *nopalera* has several meanings. It can refer to a piece of land where *nopales* cacti grow. In Mexico, the *nopal* is a symbol of cultural identity. *Nopalera* is a word used for a person whose "nopal" is undeniable.[2] It can be employed lightheartedly to refer to someone with great national pride. But it might also be used pejoratively, as a racialized adjective, to refer to a Mexican with Indigenous features. In the American Southwest, to be called a *nopalero/a* is to be marked as the Other. By referencing Kahlo's artwork, Buentello establishes a link with the Mexican painter and provides an example of kinship among artists. The two of them share a common cultural heritage and rely on art to assert their presence and raise their voice.

Taína Caragol

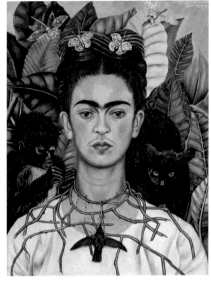

Frida Kahlo
Self-Portrait with Thorn Necklace and Hummingbird, 1940
Oil on canvas, 61.3 × 47 cm (24 ⅛ × 18 ½ in.)
Nicholas Murray Collection, Harry Ransom Humanities Research Center, the University of Texas at Austin

»
Ruth Leonela Buentello
Nopalera, 2020
Acrylic and latex on panel
101.6 × 91.4 cm (40 × 36 in.)
Courtesy of the artist

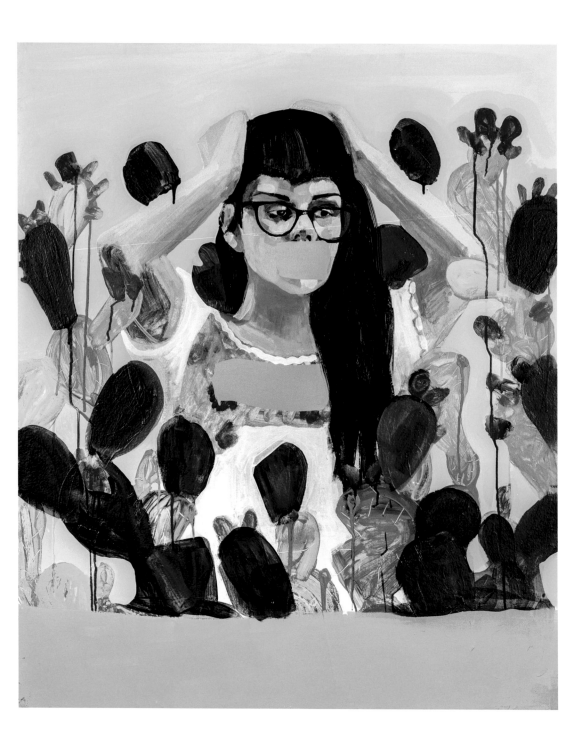

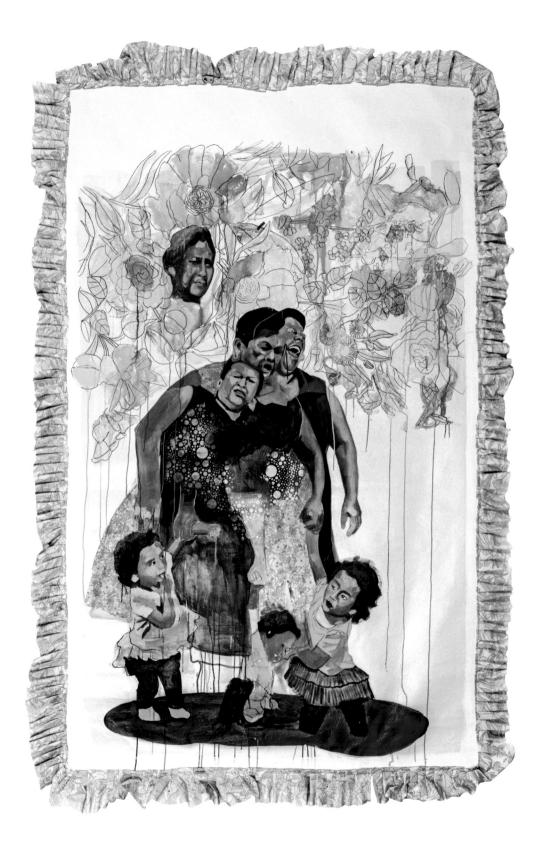

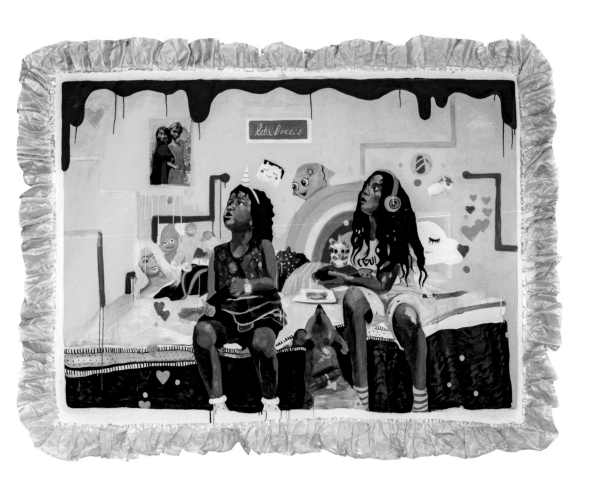

«
Ruth Leonela Buentello
Entender de dónde
nace tu manera de ser
(Understanding where
your selfhood
comes from), 2020
Acrylic on canvas with fabric
213.4 × 152.4 cm (84 × 60 in.)
Courtesy of the artist

Ruth Leonela Buentello
Gamer Niñas, 2019
Acrylic on canvas with fabric
152.4 × 203.2 cm (60 × 80 in.)
Courtesy of the artist

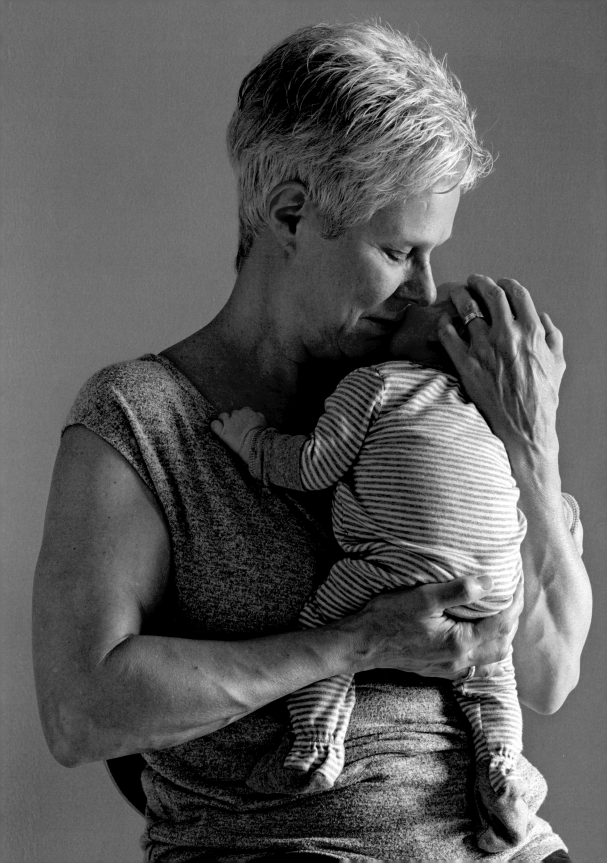

Jess T. Dugan

born 1986, Biloxi, Mississippi
based in St. Louis, Missouri

Family Pictures is a long-term project (2012–ongoing) focusing on three generations of my family: my partner, Vanessa, and me; our daughter, Elinor; my mother, Diana, and her partner, Chris. I am interested in the complexity of these relationships, both given and chosen, and how they change over time. While these photographs are highly personal, they also address the broader lack of representations of queer families in society.

I began this project in my mid-twenties. The photographs with my mother explored my relationship with her from a child's vantage point, and the photographs with Vanessa captured our relationship in its early years. Over the past decade, these relationships have deepened and evolved significantly. Becoming a parent in 2018 fundamentally changed how I view myself, and it transformed my understanding of family and my orientation to the world. The new experience of simultaneously being a child and a parent has altered my relationship with my mother, and parenting Elinor has thrown aspects of my own childhood into heightened relief, causing me to revisit memories and feelings from my past.

Another undercurrent in my work about my family—and one that is not visible here—is my estrangement from my father, resulting from his failure to accept my relationship with Vanessa and our desire to raise a child together. I am actively working to be a different parent to Elinor than he was to me: to support her, nurture her, and love her unconditionally.

J ess T. Dugan's protective gaze meets us through the hazy imprint of a screened door. With fingers outstretched across their infant's back, they tenderly wrap their right arm around baby Elinor's legs. The embrace is punctuated by the adult pinky finger delicately encircling the tiny right foot. With a slight tilt of the head, the subjects' cheeks melt together. Their pose poetically iterates the dichotomy that Dugan's composition establishes between interior and exterior; Elinor faces inward while Dugan looks outside. The parent-child bond is palpable in their closeness and further accentuated by the architectural framing device. Serving as a shield, the screen door separates inside from outside and outlines a distinct psychological and physical space. The light streaming through the window in the background brings the outside *in* and frames Elinor with a warm glow.

Through the door, the artist stages an opportunity for viewers of the photograph to reflect on the relationship between normative expectations of viewing and the connections that bind us. The screen amplifies what Dugan describes as "the photographic desire to be seen" and prompts us to consider how we intersect with each other spatially, psychologically, and physically.

For the past two decades, Dugan has focused their photography practice on the power of queer representation. Not only do they make portraits, but they also ensure that they are accessible and seen as a form of activism: "My first experiences with images of queer people, with images that validated my identity as a queer person and a nonbinary person, were in fine art photography books. Seeing someone represented who you can relate to or who validates your identity can be incredibly powerful. It can be a lifeline. It can affirm something about yourself that you're trying to figure out or understand."[1]

Dugan has worked on various projects that explore gender and sexuality and is particularly interested in how intimacy intersects with social life. The focus of their work is to recognize those "who are living authentically ... especially ... when living authentically for them requires actively working against society or the status quo."[2]

In *Family Pictures* (2012–ongoing), Dugan turns the lens on their own growing family. The images feature self-portraits, images of the artist's mother, Diana, and her partner, Chris; Dugan's spouse, Vanessa; and their child, Elinor. Together, these portraits celebrate their queer family's intimate moments and establish

»
Jess T. Dugan
Self-portrait with
Elinor (screen), 2018
Inkjet print
101.6 × 76.2 cm
(40 × 30 in.)
Courtesy of the artist

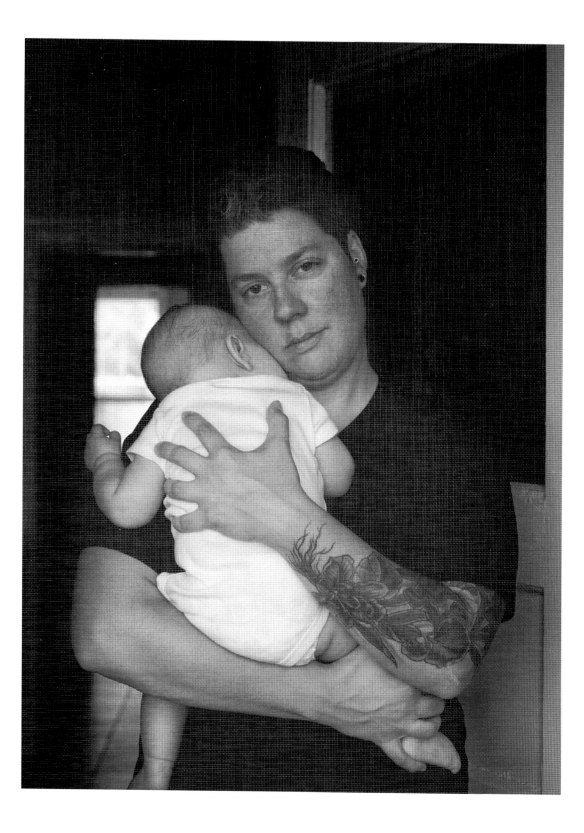

new frameworks for picturing queer and gender-expansive families in portraiture. It is a project that affirms the individual while commenting on broader family connections and the notion of kinship. In the process of picturing queer family structures, Dugan succeeds in exposing universal truths.　　　Dorothy Moss

Jess T. Dugan
Early morning light, Boston, 2020
Inkjet print
76.2 × 101.6 cm (30 × 40 in.)
Courtesy of the artist

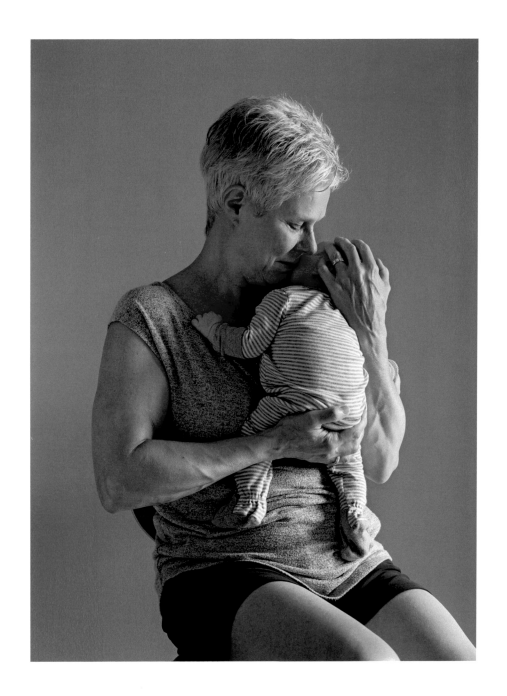

Jess T. Dugan
Mom holding Elinor
(one month), 2018
Inkjet print
101.6 × 76.2 cm
(40 × 30 in.)
Courtesy of the artist

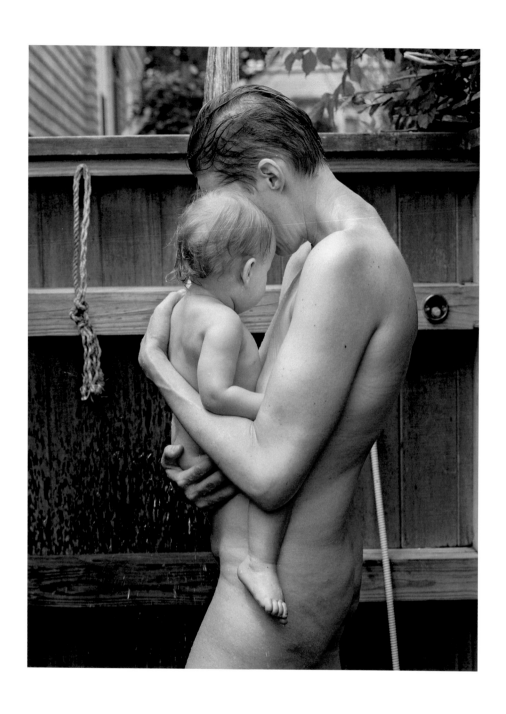

Jess T. Dugan
*Vanessa and Elinor in the
shower, Provincetown, MA*, 2019
Inkjet print
101.6 × 76.2 cm (40 × 30 in.)
Courtesy of the artist

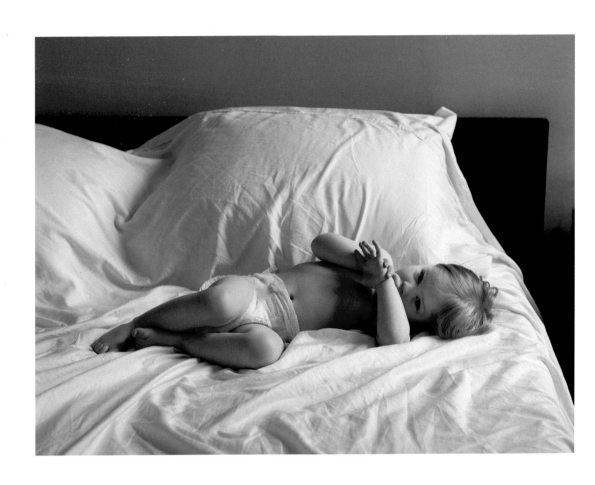

Jess T. Dugan
Elinor on the bed, 2020
Inkjet print
76.2 × 101.6 cm (30 × 40 in.)
Courtesy of the artist

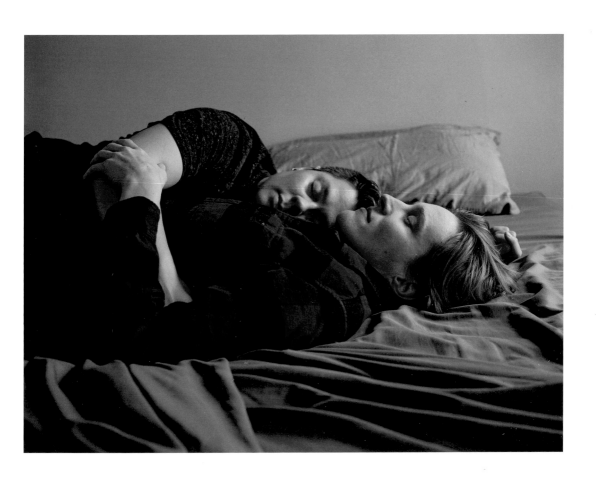

Jess T. Dugan
Self-portrait with Vanessa, 2020
Inkjet print
76.2 × 101.6 cm (30 × 40 in.)
Courtesy of the artist

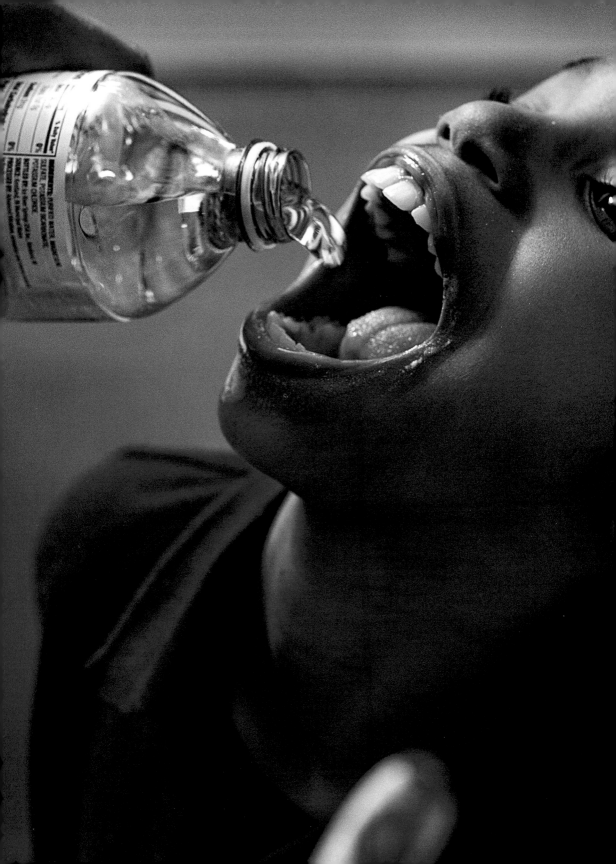

LaToya Ruby Frazier

born 1982, Braddock, Pennsylvania
based in Chicago, Illinois

I titled this series *Flint Is Family* to underscore that I see the Cobb family as kindred spirits. My previous series, *The Notion of Family* (2001–14), centered on the relationships between my grandmother, my mother, and myself, who represent three generations of Black women in Braddock, Pennsylvania. The systemic abuse my family endured in the historic steel mill town is no different from what Shea's family had to stare down in the automotive town. It is always intentional that I am not far removed from the subjects in my work and practice. I collaborate in order to tell these stories, which are a testimony of the systems that violate our human rights. I seek to redefine strength in family and kinship despite the odds that my family, my community, and I might not persevere.

From the very moment we met, Shea Cobb and I knew we were kindred creative spirits, and our common lineage and shared experiences enabled us to combine forces through photography and poetry. Together, we could defend the humanity of Shea's family and community during the worst manmade crisis in U.S. history.

It is not a coincidence that Shea and I bonded over our grandmothers, Hazel and Ruby, and over our unconditional love for our mothers, Reneé and Cynthia. And when I first locked eyes with Shea's eight-year-old daughter, Zion, I immediately discerned that she was spiritually assigned to me. When I was her age, I lacked the power and voice to fight back against the contamination of the water supply in Braddock.

It was crucial that I remained actively involved with Shea and Zion over the next five years, which is the time it took to see the indictment of elected officials responsible for the water crisis. During this period, I produced a photographic archive that Zion will inherit, one that not only reflects but proclaims that the women in her family are not victims but rather victors. I created *The Notion of Family* to ensure that my family legacy would survive and triumph over this historic erasure. If Zion ever stumbles and loses her way, I hope she will turn to *Flint Is Family In Three Acts* and remember that no weapon formed against her can prosper.

When the residents of Flint, Michigan, opened their taps in 2014, they detected something terribly wrong, but it would take almost two years for state and federal officials to declare the Flint Water Crisis an emergency. In the meantime, each drop of discolored, fetid water compromised the well-being of the city's inhabitants.[1]

The artist LaToya Ruby Frazier arrived in Flint in the summer of 2016 and spent over five months engaging with three generations of the Cobb family.[2] She became intimately familiar with their situation, witnessing how the water crisis affected them and their community. Frazier has said that she felt a responsibility to document Shea Cobb's story so that when Cobb's daughter, Zion, is an adult, she can "look back at this history" and see herself as a "victor" and "champion."[3] Working on what became *Flint Is Family In Three Acts* (2016–21) proved to Frazier that "a camera can extract the light and turn a negative into a positive."[4]

As Frazier has recalled, her very first meeting with Shea Cobb felt like a "double portrait." The two of them sat across from one another, at Cobb's favorite diner in Flint, and exchanged stories about their lives.[5] This sense of kinship becomes a triple portrait in *Self-Portrait with Shea and Her Daughter, Zion, in the Bedroom Mirror, Newton, Mississippi*, part of the second act of *Flint Is Family*. Frazier expanded her photographic survey in 2017 to include Shea and Zion's move to Newton, Mississippi, where they hoped to find clean water, and with it, stability.

Taken at the home of Shea Cobb's father, Douglas R. Smiley, this is the first time in the series that Frazier presents herself in a composition. Her likeness is small but discernible. She appears in the background mirror, sharing the space with Zion and Shea. In the foreground, Shea's direct gaze comes across through the reflection of a mirror propped on a wooden dresser. Her back shows up in the distant mirror, as she and the other figures occupy one reflective surface after another. Through this play of mirrors and reflections, Frazier brings into full view her kinship with the family and Flint's residents. She reminds us of her and her family's experiences with industrial neglect, which she chronicled in her earlier series *The Notion of Family* (2001–14).[6]

This self-portrait is by no means the conclusion of the photographer's engagement with Flint's people. In 2019, in what Frazier has noted as an example of "creativity and solidarity," she collaborated with Shea Cobb, Amber Hasan, and Moses West to bring an atmospheric water generator to Flint's residents. So far, this contribution has made thousands of gallons of clean water free and accessible. Leslie Ureña

»
LaToya Ruby Frazier
Self-Portrait with Shea and
Her Daughter, Zion, in the
Bedroom Mirror, Newton,
Mississippi, 2017–19
from "Flint Is Family
In Three Acts"
Gelatin silver print
76.2 × 101.6 cm
(30 × 40 in.)
Courtesy of the artist
and Gladstone Gallery

LaToya Ruby Frazier
Flint Is Family, 2016
from "Flint Is Family In Three Acts"
Video, color with sound, 11:50 min.
Courtesy of the artist and
Gladstone Gallery

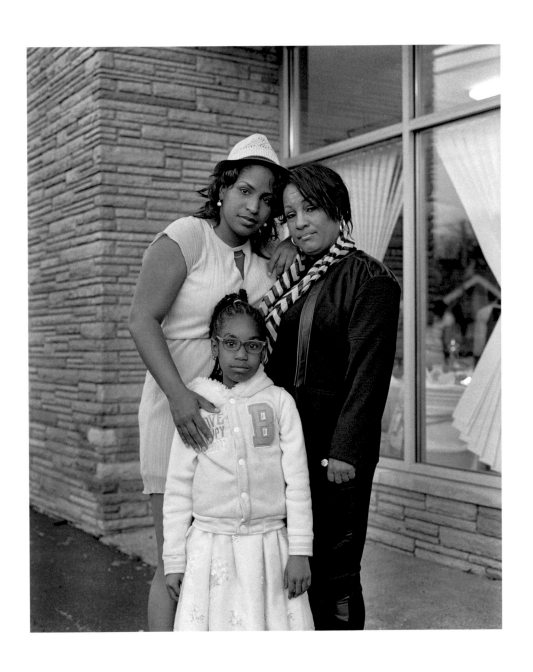

LaToya Ruby Frazier
Shea Cobb with Her Mother, Ms. Reneé, and
Her Daughter, Zion, at Nephratiti's Wedding
Reception, Standing Outside the Social Network
Banquet Hall, Flint, Michigan, 2016–17
from "Flint Is Family In Three Acts"
Gelatin silver print
101.6 × 76.2 cm (40 × 30 in.)
Courtesy of the artist and Gladstone Gallery

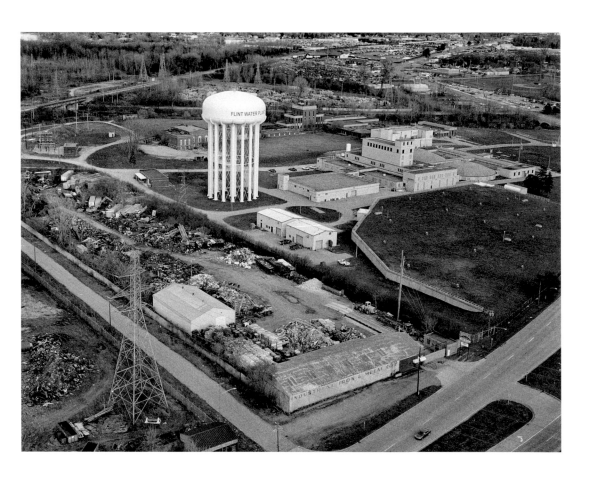

LaToya Ruby Frazier
The Flint Water Treatment Plant,
Flint, Michigan, 2016–17
from "Flint Is Family In Three Acts"
Gelatin silver print
50.8 × 61 cm (20 × 24 in.)
Courtesy of the artist and
Gladstone Gallery

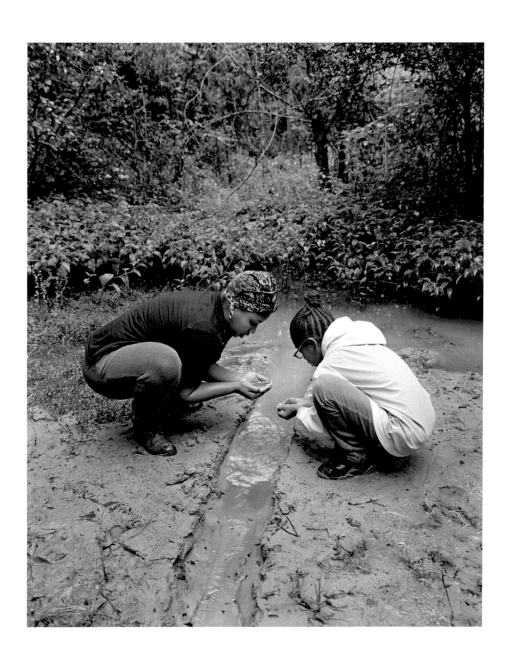

LaToya Ruby Frazier
Shea and Her Daughter, Zion, Sipping
Water from Their Freshwater Spring,
Newton, Mississippi, 2017–19
from "Flint Is Family In Three Acts"
Gelatin silver print
61 × 50.8 cm (24 × 20 in.)
Courtesy of the artist and
Gladstone Gallery

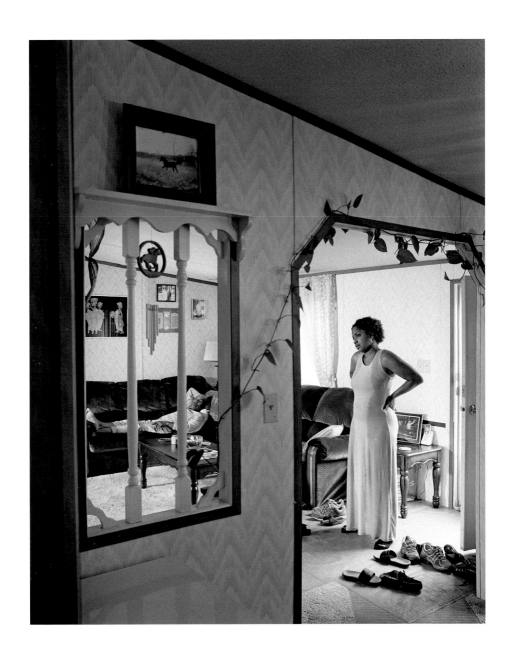

LaToya Ruby Frazier
Shea and Her Father, Mr. Smiley,
in His Living Room, Newton,
Mississippi, 2017–19
from "Flint Is Family In Three Acts"
Gelatin silver print
61 × 50.8 cm (24 × 20 in.)
Courtesy of the artist and
Gladstone Gallery

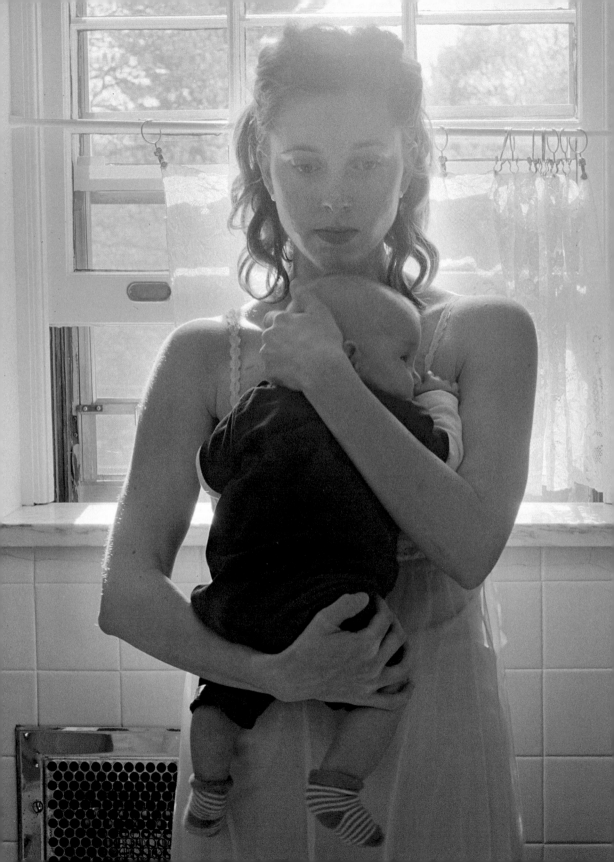

Jessica Todd Harper

born 1975, Albany, New York
based in Philadelphia, Pennsylvania

Like the seventeenth-century Dutch painter Johannes Vermeer, who imbued ordinary interiors with meaning and beauty, I look for the worth in everyday moments. The characters in my imagery are those around me—my friends, my family, and myself—but it is not so much the people who are the focus of my portraits as the way in which they are organized and lit. A woman standing in a messy bathroom with a baby is not a particularly sacred moment, but as in a Vermeer painting, the composition and lighting influence the content to suggest otherwise.

Most of the time, everyday scenes don't mean anything to us. In fact, it is a modern truism that we seek distraction from them. We scroll through our phones rather than sit alone with our thoughts, ourselves, or even our families. But sometimes, our unexamined—even boring—surroundings can be illuminated. One thinks of Plato's notion of the Ideal, Kant's discussion of the Sublime, or Vermeer's paintings of domestic life. One of the most satisfying of human experiences is to imagine that the world around us means more than what we see at first glance, that it points to something transcendent. And in my imagery, I am trying to do just that.

Because this body of work spans more than twenty years, viewers of my photographs also experience the passage of time. Babies grow into teenagers. Grandparents die. In this way, my imagery alludes to another seventeenth-century Dutch theme, that of the memento mori; life is a beautiful—and brief—opportunity.

Cycles of family life flow through Jessica Todd Harper's photographs. As one generation transitions to the next, we see new lives begin and others end. Children lean into the future, providing glimpses of the adults they are to become. Fleeting effects of natural light enhance the impression of ephemerality in these images of temporality and change, while Harper's carefully composed scenes suggest the enduring significance that a single moment may possess. Her photographs sensitize us to the special bonds of intimacy and vulnerability that define kinship. At the same time, these portraits convey the impenetrable nature of their subjects' interior worlds, suggesting how private thoughts and feelings differentiate each individual's experience as uniquely their own.

In *The Dead Bird*, the artist's mother and her young daughter, Catherine, ponder the mortality of a female Downey woodpecker. Although the figures are visually unified—both dressed in blue, angling their bodies toward one another, their arms converging on the dead bird—each brings her own private perspective to this shared experience.

With furrowed brow and pressed lips, the older woman gazes down at the bird with an expression of sorrowful concern. She supports the bird's body with one hand, cradling its head in her fingertips. With the other, she tenderly touches its feathers. The instinctive compassion of her response suggests a long history of providing comfort and care. A lifetime's experience is evident in her lined face and hands, the gray strands of her hair, and her wedding ring. The encounter with the dead bird seems to strike a deep emotional chord, perhaps reviving well-worn memories of past grief.

The young girl, by contrast, probes the bird's body with curiosity. Grasping a wingtip between two fingers, she unfurls the feathers, displaying the black-and-white pattern and the bony armature that enabled the miracle of flight. It is a moment of revelation in more than one sense. While her grandmother remains focused on the bird, Catherine fixes us with a wide-eyed stare. Her unblinking gaze and parted lips suggest a sudden realization, frozen in time by the camera. Looking beyond her world and into ours, she directs attention to the lifeless bird, solemnly bearing witness to the fragility of life and the finality of death.

In the background, a tree's radiating limbs create an exuberant fan of greenery, obscuring all but the legs of a boy climbing through

Jessica Todd Harper
The Dead Bird, 2018
Inkjet print
67.6 × 101.6 cm
(26 5/8 × 40 in.)
Courtesy of the artist

the branches. Close-set brick houses nestled among the foliage suggest a sheltered suburban neighborhood. The idyllic backdrop contrasts with the drama of lost innocence and hard-won experience in the foreground. In this modern retelling of the ancient *Et in Arcadia ego* theme, death is revealed as an inescapable presence, even in the arcadian setting of an American suburb.

The organic relationship of life and death informs much of Harper's work. Her photographs reflect a keen awareness of time's constant march and of mortality as the touch of nature that makes the whole world kin. Yet by emphasizing the mysterious interiority of the human mind and the continuities of families across generations, she imbues her artfully constructed scenes of daily life with an aura of transcendence. Robyn Asleson

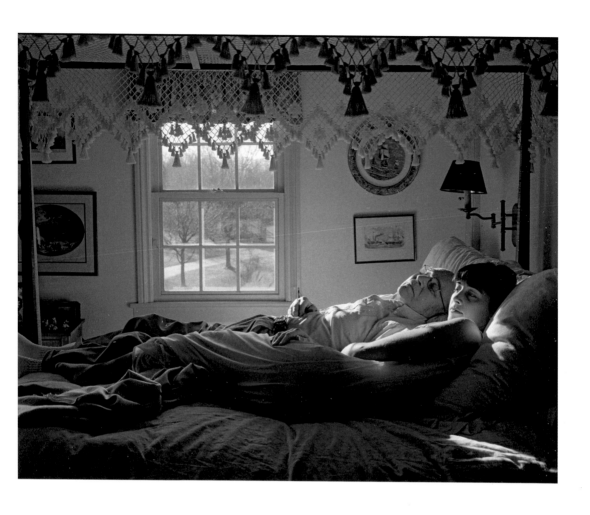

Jessica Todd Harper
Becky with Papa, 2007
Inkjet print
81.3 × 101.6 cm (32 × 40 in.)
Courtesy of the artist

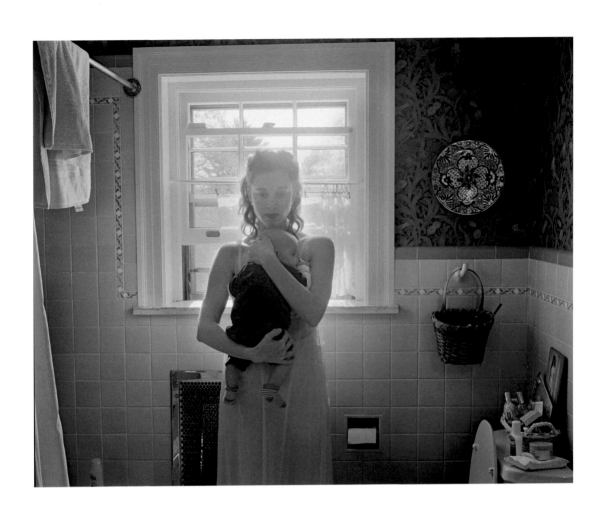

Jessica Todd Harper
Self-Portrait with
Marshall, 2008
Inkjet print
81.3 × 101.6 cm (32 × 40 in.)
Courtesy of the artist

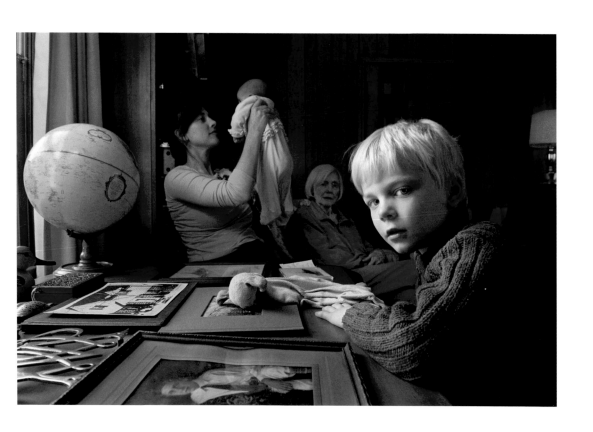

Jessica Todd Harper
*Marshall with Family
and the World*, 2013
Inkjet print
67.6 × 101.6 cm (25 ⁵/₈ × 40 in.)
Courtesy of the artist

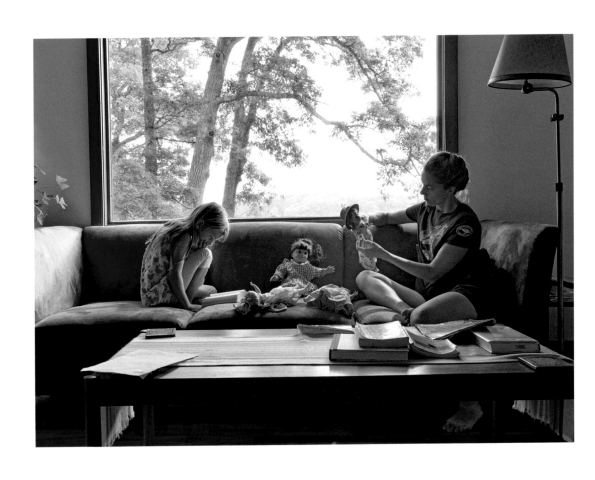

Jessica Todd Harper
Self-Portrait with
Catherine and Dolls, 2018
Inkjet print
73.7 × 101.6 cm (29 × 40 in.)
Courtesy of the artist

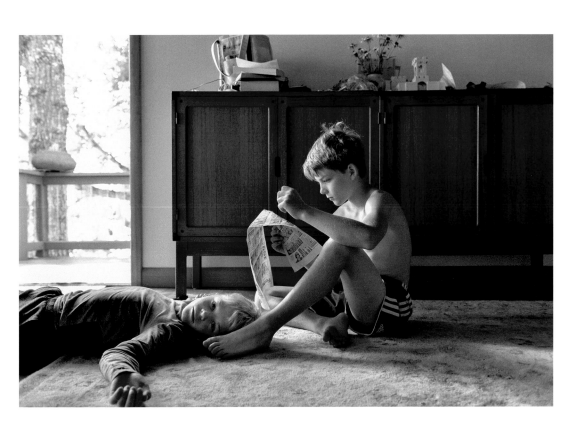

Jessica Todd Harper
Comics, 2020
Inkjet print
67.6 × 101.6 cm (26 5/8 × 40 in.)
Courtesy of the artist

Thomas Holton

born 1969, Guatemala City, Guatemala
based in New York City

As social beings, we all crave a sense of belonging. From friendships to the workplace to our families, we desire to be wholeheartedly welcomed as our true selves. Half-Chinese and half-American, I have never felt a complete kinship with my Chinese heritage. This sense of disconnection has been a constant part of my life.

I am a lifelong New York City resident and, since childhood, have had relatives living in Chinatown, but I never lived in the neighborhood and always felt a distance between my Chinese family and me. As an adult, I began to explore my identity. I visited Chinatown regularly, hoping that, through deeper relationships and experiences, I could better understand myself. In 2003, I was lucky enough to meet the Lams, a Chinese family, who welcomed me into their lives. My life has not been the same since.

Over time, I have learned to love the Lams as much as my own family. Witnessing the years of the Lam children's adolescence and the usual and unusual challenges of their parents' marriage, I have grown both as an artist and as a human. Be it picking up the children from grade school, eating at the family's boisterous dinner table, or driving the children to college, I have personally felt the importance of connection. The Lams have made me feel like family.

This powerful sense of belonging to something bigger than myself is what kinship means to me. *The Lams of Ludlow Street* has moved beyond a mere project and is now a part of my life that makes me complete. Despite the inevitability of changing family dynamics, I will always make new photographs of the Lams as our lives continue this beautiful and unscripted journey.

Families experience moments of fracture and displacement in transitions, such as when a family member dies or a marriage breaks up. Since 2003, photographer Thomas Holton has documented his relationship with the Lam family of Chinatown in the series *The Lams of Ludlow Street*. Following life's shifts, he has portrayed them in times of cohesiveness and brokenness, during reunions and separations. The dissolution of Steven and Shirley Lam's marriage in 2010 marked a turning point in his connection with the family. *Steven's Walk-In Closet* captures two of its members, Cindy and Michael, sharing a divided space while the bond they share as siblings unites them psychologically, spatially, and compositionally.

A long, narrow mirror leads the viewer into the photograph, which was taken on the photographer's first trip to Steven's new apartment in New Jersey. Cindy, then in eighth grade, was amazed by the larger space. It had a walk-in closet as large as a bedroom— a stark contrast with the family's cramped Chinatown tenement, where she had lived since birth. During the visit, Holton noticed Cindy looking out from the interior of the closet into the bedroom as her older brother lounged on the bed. It was a stunning composition, and he asked them to hold the pose. The artist later noted, "Fleeting glances. Overlapping feet. Staring eyes. As I got to know them better, the mindful search for these moments sustained me for years."[1] Here, as the siblings adjust to their father's new living arrangement, apart from their mother, they are vigilant, watching out for one another, always holding each other within eyesight. They participate willingly in Holton's project and write their own narrative through his gaze.

As the children grew accustomed to the changed situation, Holton noticed how their emotional distance manifested in their surroundings. Bunkbeds, makeshift walls, and other physical barriers began to appear in the portraits as a way to heighten the psychological tension. Family members pause in doorways and glance into mirrors as they navigate their splintered dynamics. Holton's interest in capturing the Lams' living quarters has become intertwined with understanding them as individuals, each trying to make their way through the chaos and beauty of life. Dorothy Moss

»
Thomas Holton
Steven's Walk-in
Closet, 2014
Inkjet print
33 × 50.8 cm
(13 × 20 in.)
Courtesy of the artist

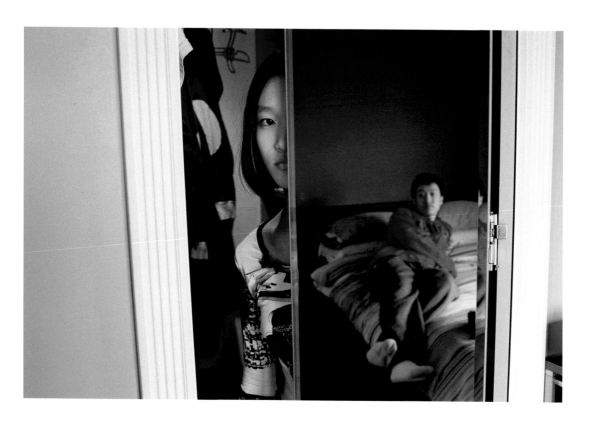

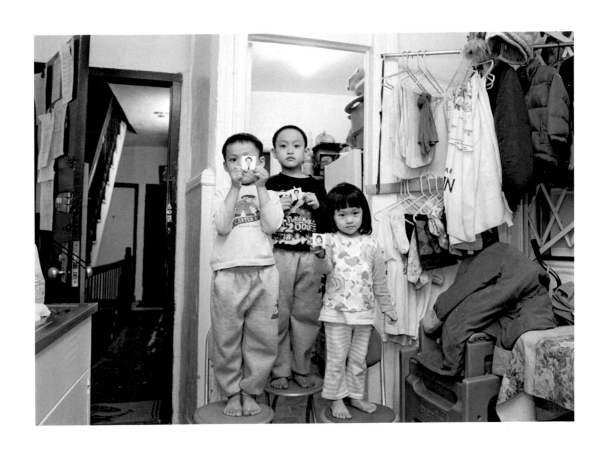

Thomas Holton
Passport Photos, 2003
Inkjet print
33 × 50.8 cm (13 × 20 in.)
Courtesy of the artist

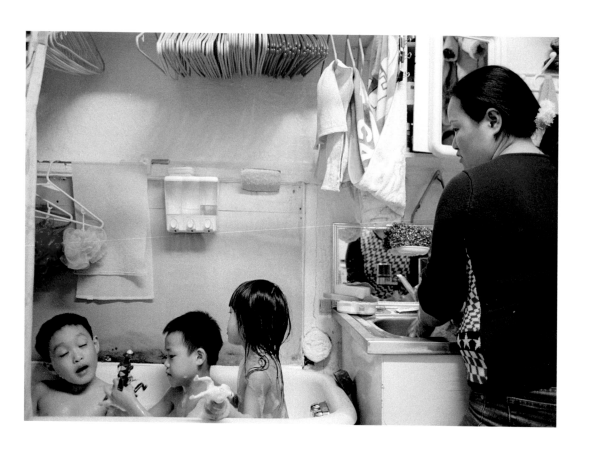

Thomas Holton
Bath Time, 2004
Inkjet print
33 × 50.8 cm (13 × 20 in.)
Courtesy of the artist

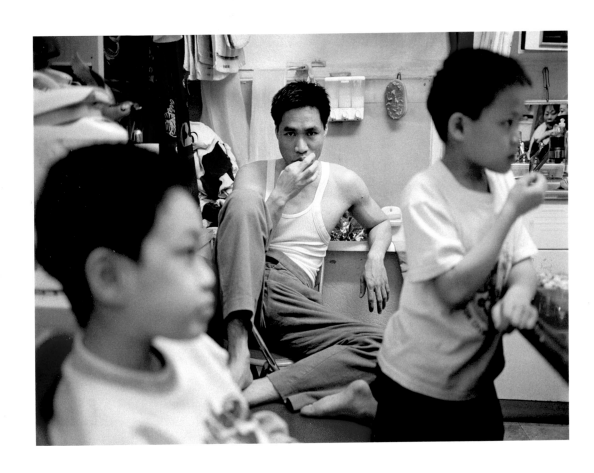

Thomas Holton
Conversation, 2005
Inkjet print
33 x 50.8 cm (13 x 20 in.)
Courtesy of the artist

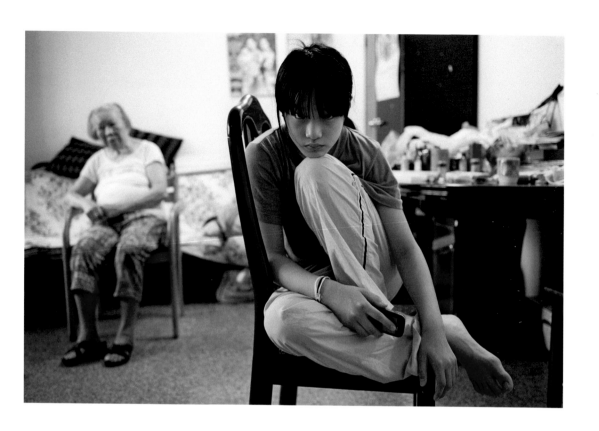

Thomas Holton
Bored, 2011
Inkjet print
33 × 50.8 cm (13 × 20 in.)
Courtesy of the artist

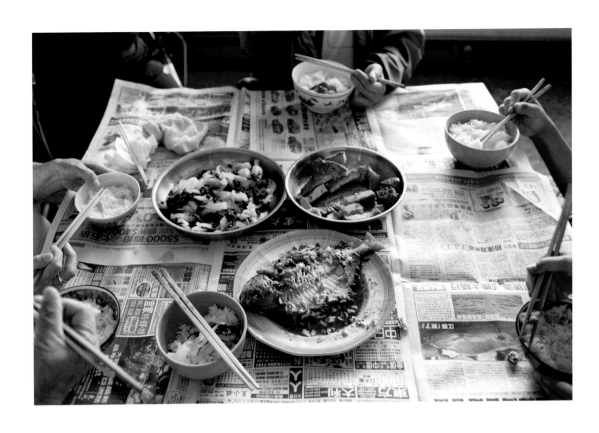

Thomas Holton
Dinner for Seven, 2011
Inkjet print
33 × 50.8 cm (13 × 20 in.)
Courtesy of the artist

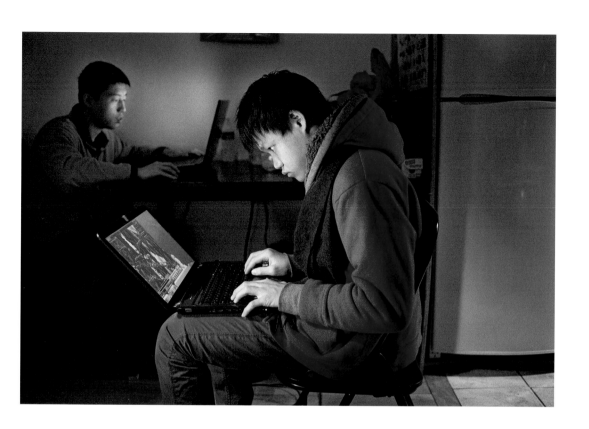

Thomas Holton
Online at a Friend's, 2011
Inkjet print
33 × 50.8 cm (13 × 20 in.)
Courtesy of the artist

Thomas Holton
College Orientation, 2014
Inkjet print
33 × 50.8 cm (13 × 20 in.)
Courtesy of the artist

»
Thomas Holton
Zooming with Cindy, 2021
Inkjet print
33 × 50.8 cm (13 × 20 in.)
Courtesy of the artist

»
Thomas Holton
Watching Black Mirror, 2019
Inkjet print
33 × 50.8 cm (13 × 20 in.)
Courtesy of the artist

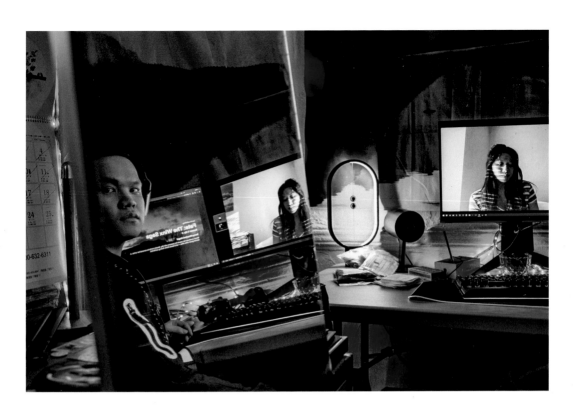

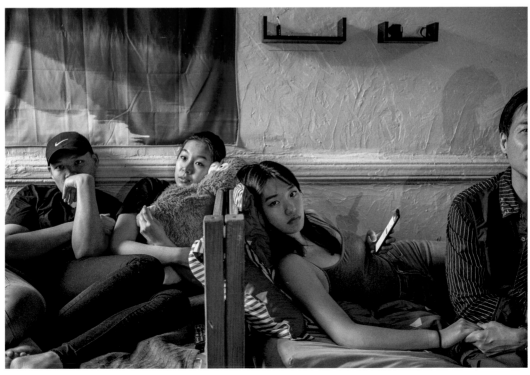

Sedrick Huckaby

born 1975, Fort Worth, Texas
based in Fort Worth, Texas

For me, kinship is family in the literal and social sense of the word. All those considered to be family are regarded as Kinfolk. Also, one has a kinship or likeness with those who share similar experiences or outlooks. Back home, Kinship is related to the term Kinfolk—an endearing term for someone who comes from the same place as you. Back in the day, we would also use the words homeboy, homegirl, or "little home" in the same way.

I think the entire human race shares in a kind of kinship with each other, and in my art, my goal is to show that the whole world is a patchwork quilt, one large community of mankind. Although we come from some very different places and perspectives, the human experience has definite shared attributes that almost all people can relate to on some level. Often my work as an artist is to help the whole world see this one thing: we are all kin. I also like to think that some form of kinship goes beyond the physicality of the word. Perhaps kinship can surpass mortality and find itself still standing long after the world as we know it passes away.

Sedrick Huckaby often thinks about the relationship between our memories of loved ones and technology's potential to rupture, or open, the space between life and death. "How many times on any day," the artist asks, has "an image popped up on a cell phone and it's this time last year, or it's this time two years ago? ... For many people, that image may be the image of a person who has passed away."[1] Huckaby recognizes the power of these moments. They can startle us out of the present and transport us to a different time and place.

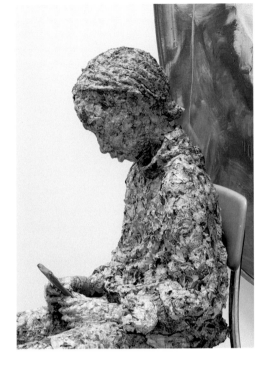

The life-size installation *Connection* represents Huckaby's daughter, Halle Lujah Huckaby, with her grandmother and great-grandmother. Sculpted with newspaper papier-mâché, Halle is shown holding a smartphone that the artist has fashioned rather crudely out of a cardboard rectangle lined in blue painter's tape. Her head is bent down toward the familiar-looking object while, behind her, a painted figure hovers in abstraction. This apparition-like image represents Halle's grandmother, Ruthie Huckaby (b. 1948), who wears a funerary T-shirt that features two images of her own mother, Hallie Carpenter (Halle's great-grandmother and the artist's grandmother; 1923–2008).

Growing up in North Texas, Huckaby affectionately called his grandmother Hallie "Big Momma." She was his primary caregiver and undoubtedly grounded his practice in "faith, family, community, and heritage."[2] Huckaby and his wife, artist Letitia Huckaby, recently restored Big Momma's one-hundred-year-old home, "Kinfolk House." The space serves a collaborative artistic community, where the spirit of his grandmother reaches people of all ages.[3] Huckaby's work honors the presence and strength of his intergenerational community, the Black and Latinx "Polytechnic neighborhood" of Fort Worth. His family members, both deceased and living, along with his neighbors, inform his work. In exchange, his art provides spiritual support and creative sustenance for them. Huckaby alludes to the depth of the bonds that connect us to loved ones who have passed away when he posits, "What if death is just another door?"[4]

Sedrick Huckaby
Connection, 2020
Painting: oil on canvas on panel, 182.9 × 121.9 cm (72 × 48 in.)
Sculpture: newspaper papier-mâché, desk chair, and cardboard on wood platform, 119.4 × 71.1 × 125.7 cm (47 × 28 × 49 ½ in.)
Courtesy of the artist and Talley Dunn Gallery, Dallas, Texas

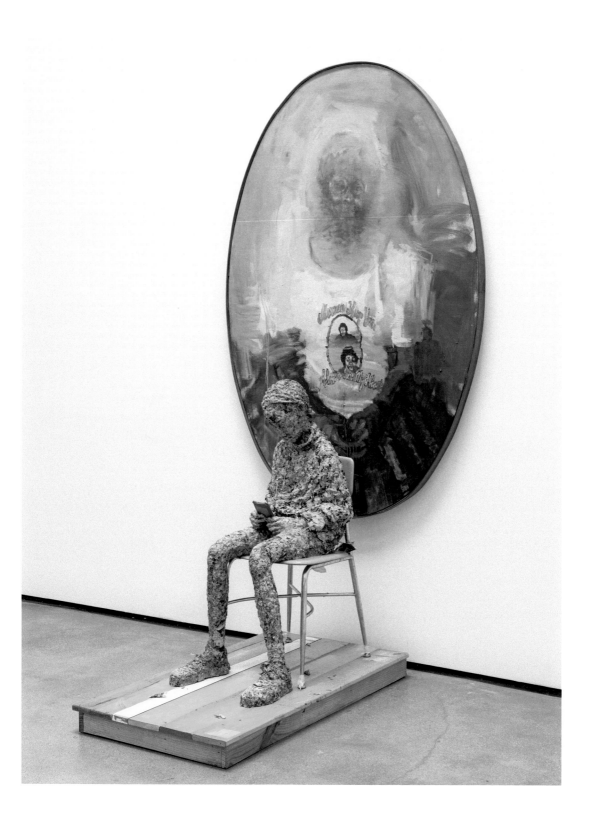

His current work combines painting and sculpture in intimate installations that visualize a portal between two worlds, with portraiture as a vehicle to collapse time. In *Connection*, Halle's grandmother and great-grandmother exist in her mind's eye through a veil, as if seen through a stream of light when a door is cracked. The artist leaves open the possibility that the painted image of Halle's grandmother is what she sees on her screen as he shines a light on the negotiation of memory and time, and even the pain of death.

While the movement and liveliness in the handling of the painted and sculpted forms bring Halle and her grandmother closer together, the portraits themselves remain physically separate. Ultimately, though, through Huckaby's dissolution of time and space, the transcendence of connection is revealed. Dorothy Moss

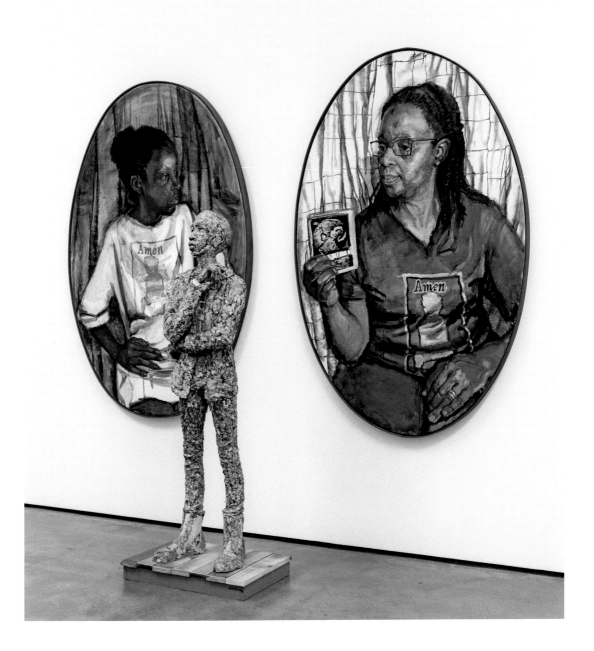

Sedrick Huckaby
AMEN, 2020
Paintings: oil on canvas on panel,
each 188 × 121.9 cm (74 × 48 in.), framed
Sculpture: newspaper papier-mâché on
wood platform, 157.5 × 30.5 × 40.6 cm
(62 × 12 × 16 in.)
Rennie Collection, Vancouver

Anna Tsouhlarakis

born 1977, Lawrence, Kansas
based in Boulder, Colorado

Throughout my work, I have continually made connections between people and ideas. Growing up in a Native family, oral traditions were alive and well. In so much that we saw and experienced, there were reminders of why we did certain things this way or that way. There were always stories about the land and people. It was natural for me to utilize these teachings as the foundation of my artistic practice. They are the jumping-off points for so many of my projects.

The Missing and Murdered Indigenous Women's movement advocates for the end of violence against Native women and brings attention to the high rate of missing and murdered Native women. Across the continent, missing posters inundate Native communities and flood social media. This epidemic has largely gone unnoticed nationally and is even overlooked by state and local governments. Many of the stories of these women are still incomplete, full of unanswered questions about their fates, with little or no follow-up from authorities. These women led meaningful lives and were community and family members.

While the women whose stories I am sharing through *Portrait of an Indigenous Womxn [Removed]* are not directly related to me, they are part of the larger Native community. As a Native woman, I feel it is my responsibility and, at the same time, an honor to help amplify their stories and oral histories. This project is not about the kinship I feel toward them, though I do feel it. It is instead centered on the kinship among Native families, particularly the connections these women had with the people in their communities—those who loved them and want their stories in the world.

The task is to write an object study for a catalogue of an exhibition full of objects: photographs, sculptures, paintings, and a video, itself contained within the frame of a flatscreen monitor. But if the object of study is performance, how do you compose such a study without an object? Can language ever adequately describe performance? Will language always fail when faced with performance because it overflows both with presence (and the present) and absence?

On the afternoon of May 5, 2023, Anna Tsouhlarakis will begin her performance in the courtyard of the National Portrait Gallery. She will quietly build a sculpture made from wood she sourced near her home in Boulder, Colorado. Using the trunks of young aspens, the artist notes that the "root systems of these trees are interconnected and grow laterally, underground and out of view."[1] The sound of her brother's voice will fill the cavernous space as he sings songs that honor and remember. After Tsouhlarakis finishes constructing the sculpture, she and her brother will proceed into the halls of the museum and place it among the portraits of individuals who, following the museum's Congressional mandate, are recognized for having "made significant contributions to the history, development, and culture of the people of the United States."

Akin to an easel, Tsouhlarakis's sculpture will display one image: a missing person poster for Kaysera Stops Pretty Places (2001–2019), a young woman who, on August 29, 2019, at age eighteen, was found dead in Hardin, Montana. It took a full thirteen days for law enforcement to contact her family. The family notified law enforcement that she was missing, but no missing person's report was filed, and after she was identified, none of her relatives were consulted. Years later, her case has yet to be solved.[2] Kaysera was a member of the Crow Nation located in the state now known as Montana, which has one of the highest rates of missing and murdered Indigenous women and girls in the country. So many of these cases remain unsolved and willfully neglected by local, state, or federal law

Anna Tsouhlarakis sourced wood for her sculpture from aspen trees near her home in Colorado. She photographed these trees in March 2022.

»
Anna Tsouhlarakis
Portrait of an Indigenous Womxn [Removed], 2021
Exhibition copy of object for performance in 2023
30.5 x 35.6 cm (12 x 14 in.)
Courtesy of the artist

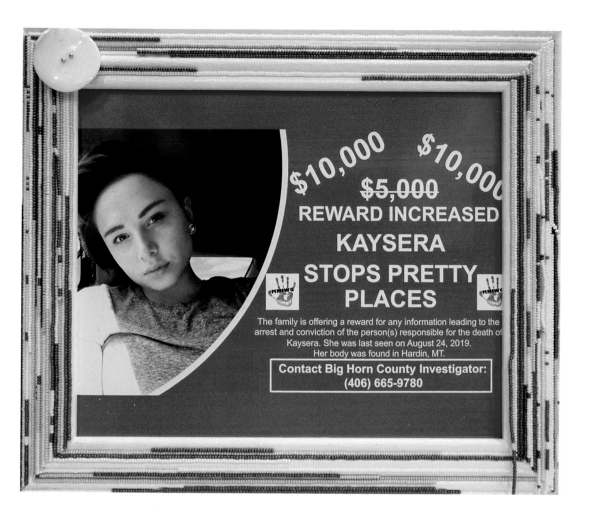

enforcement.[3] Having lived in Washington, D.C., for many years, Tsouhlarakis never encountered any portraits of *and* by Native people at the museum. As the artist points out, this portrait of Kaysera Stops Pretty Places would probably not have a place in the National Portrait Gallery's permanent collection, save for the few hours between when the artist situates it in the museum and when she takes it away at day's end.

Tsouhlarakis specifically chose to perform on May 5 because it is Missing and Murdered Indigenous Persons Awareness Day, as mandated by a presidential proclamation that went into effect in 2021, along with the Not Invisible Act.[4] The day is itself a performative utterance of recognition and authority, a single twenty-four hours to remember thousands of women and girls. One day—and one brief artist's performance—to bring presence to a profound, incalculable, and ongoing absence. Charlotte Ickes

Endnotes

Njideka Akunyili Crosby

1 Njideka Akunyili Crosby quoted in Ian Berry, "Generation Shift: A Dialogue with Njideka Akunyili Crosby," in *Njideka Akunyili Crosby: Predecessors*, eds. Ian Berry and Steven Matijcio (Saratoga Springs, NY: Frances Young Tang Teaching Museum and Art Gallery at Skidmore College, 2019), 10.
2 Ibid., 11.
3 Njideka Akunyili Crosby quoted in Diane Solway, "Painter Njideka Akunyili Crosby Is Painting the Afropolitan Story in America," *W Magazine*, August 15, 2017, wmagazine.com. Also see Malik Gaines, "Interior Grammar," in *Akunyili Crosby: Predecessors*, 20.
4 Akunyili Crosby has stated that the overarching theme in her work "is this point of union between two cultures." See "Njideka Akunyili Crosby on Painting Cultural Collision," SFMOMA, May 2015, youtube.com (esp. 0:37 min).
5 For the reference on the artist's mother's name, see Chidiogo Akunyili-Parr, *I Am Because We Are: An African Mother's Fight for the Soul of a Nation* (Toronto: Anansi, 2022), 21–22. For the reference on the Igbo term, see author's email correspondence with Erin Manns, September 16, 2021.
6 Coincidentally, this portrait was made close to the time when Akunyili Crosby was challenging herself to make portraits. See "at home: Artists in Conversation | Njideka Akunyili Crosby,"

Yale Center for British Art, June 16, 2021, youtube.com (esp. 6:40 min.).
7 See Akunyili Crosby, "Generation Shift," 11.
8 For more on Akunyili Crosby's process, see "at home" (esp. 48:38 min.).
9 For more related to the "hybrid world," see Akunyili Crosby, "Generation Shift," 15–16.

Ruth Leonela Buentello

1 Email from Ruth Leonela Buentello to author, April 10, 2022.
2 According to Aztec mythology, the god Huitzilopochtli told his people to migrate south from their original land of Aztlán and only settle when they encountered an eagle seated on a nopal cactus while eating a serpent. There, they would found the city of Tenochtitlán, which today is Mexico City. For this reason, the nopal cactus is foundational to the story of Mexico, and the nopal with the eagle eating the serpent appears at the center of the Mexican flag.

Jess T. Dugan

1 See Jess T. Dugan, "Brief But Spectacular," PBS Newshour with Judy Woodruff, January 20, 2022, pbs.org.
2 Ibid.

LaToya Ruby Frazier

1 In 2014, forty percent of Flint's residents were living below the poverty line. For timelines of the Flint water crisis, see Merrit Kennedy, "Lead-Laced Water in Flint: A Step-by-Step Look at the Makings of a Crisis," April 20, 2016, npr.org. Also see *Associated Press*, "Key Moments in Flint, Michigan's Lead-Tainted Water Crisis," January 12, 2021, apnews.com.
2 See LaToya Ruby Frazier, "A Creative Solution for the Water Crisis in Flint, Michigan," *TED*, September 2019, ted.com.
3 LaToya Ruby Frazier, "What Is the Human Cost of Toxic Water and Environmental Racism?," *TED Radio Hour*, August 7, 2020, npr.org.
4 See LaToya Ruby Frazier et al., *Flint Is Family In Three Acts* (Göttingen: Steidl; Pleasantville, New York: The Gordon Parks Foundation, 2022). Also see Frazier, "A Creative Solution."
5 See Frazier, "What Is the Human Cost?"
6 See LaToya Ruby Frazier, Dennis C. Dickerson, Laura Wexler, Dawoud Bey, and Lesley A. Martin, *The Notion of Family* (New York: Aperture, 2016).

Thomas Holton

1 Thomas Holton, "The Lams of Ludlow Street," in Thomas Holton, Charles Traub, and Bonnie Yochelson, *The Lams of Ludlow Street* (Heidelberg: Kehrer, 2016 [2015]), n.p.

Sedrick Huckaby

1 Sedrick Huckaby, "*Estuary* Walkthrough," Philip Martin Gallery, April 21, 2021, philipmartingallery.com/video/34/.
2 See the artist's website, huckabystudios.com/about/sedrick.
3 See the website for Kinfolk House, kinfolkhouse.org.
4 See Huckaby, "*Estuary* Walkthrough."

Anna Tsouhlarakis

1 Email from Anna Tsouhlarakis to authors, March 23, 2022.
2 For further information about the case, see "Kaysera Stops Pretty Places" on the website of Pipestem & Nagle, P.C., pipestemlaw.com/kaysera-stops-pretty-places/.
3 See "Aunt of Slain Crow Woman Kaysera Stops Pretty Places Calls for Further Investigation into Her 2019 Death," September 11, 2021, nbcnews.com.
4 See "Secretary Haaland Continues Pursuit of Justice in Indian Country, Begins Implementation of 'Not Invisible Act,'" U.S. Department of the Interior, April 22, 2021, doi.gov. Also see "A Proclamation on Missing and Murdered Indigenous Persons Awareness Day, 2021," The White House, May 4, 2021, whitehouse.gov.

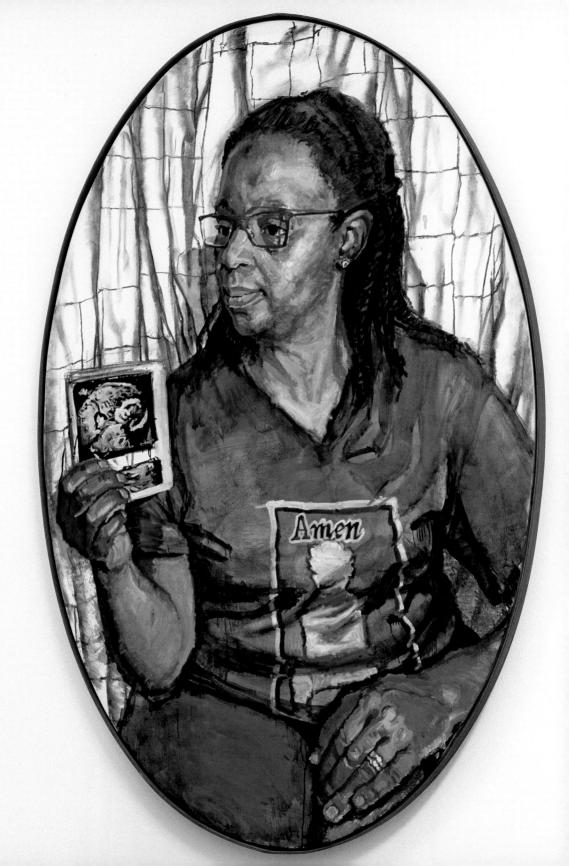

Kinship: In Conversation (Part I)

Jess T. Dugan, Thomas Holton, and Sedrick Huckaby

Interviewed by Taína Caragol, Charlotte Ickes, Dorothy Moss, and Leslie Ureña

This conversation was held via Zoom on November 9, 2021. The following transcript has been edited for length and clarity.

UREÑA: Thank you all so much for joining us today.

MOSS: Yes. I'm so happy that this is finally happening. I respect and admire all of your work so much. And I think this will be a really moving exhibition, especially given the timing—we never knew we were going to face coming out of this pandemic.

UREÑA: So, I'll just get started. Looking at the questions that we shared with you, the first thing I would like to ask is, how does your notion of kinship shape your practice? Sedrick, go for it.

HUCKABY: So a lot of my pieces have to do with the Black family and the issues that families face. There's a level of kinship that has to do with family specifically, the family unit. But if you look at it, you have those people who are family, but they're not blood relatives. They are family because of their closeness to you.

Here, where I'm from, if you're from the neighborhood that we come from or the area, a person will call you kinfolk. And they just use [the term] to describe a person who's from the area that you're from. It's describing a kind of closeness.

ICKES: What Sedrick is discussing relates to a question about how your specific location affects how you think about kinship in your work.

HUCKABY: I'm often making art about my very own household. It branches out from there to include thoughts about my community, my neighborhood, my city, and expands to all of the communities that I consider myself to be a part of. When you follow it all the way out, it's kind of about making the whole world into kinfolk or finding how the whole world has a likeness.

MOSS: Sedrick, I think, you were already so grounded in your neighborhood, in your kinfolk, in your place. Now Tom, you've mentioned that you've been in search of kinship, in a way.

HOLTON: Yes. A big part of kinship, for me, is the sense of belonging. A huge defining factor in my photography is having this space to go to, having a space where I wanted to explore, but more importantly, I wanted to feel like I was welcome. So it has been a search for kinship, and it's interesting because in photography, you seek out to do this, but then the photographs bring you somewhere else, right?

UREÑA: Thank you. I'm going to take the photography cue and turn to Jess. In terms of your series, it would be great to hear more about how kinship influences your work.

DUGAN: I love so many things that Sedrick and Tom said. I was thinking about the idea of kinship as being about relationships between people, and those relationships taking different forms.

The idea of connecting and relating is essential to my work. And, I hadn't thought of this in advance, but when Sedrick was talking about the term kinfolk, it reminded me how in queer communities, we use the word family, like, oh, I'm looking for queer family, or she's family. So, there's this way of interchanging those words and seeking a sense of familiarity or belonging, even with people you don't know, or people you aren't already connected with.

UREÑA: That's great. Thank you. And Jess, I'd love to hear more about working with your family in terms of creating this series.

DUGAN: I've always used photography as a way to understand myself and my place in the world, and as a way to make sense of my own identity and my relationships with other people. This body of work, in particular, depends upon the passage of time. I am photographing the same people, trying to show our relationships as well as make different kinds of photographs over a long period of time.

When Vanessa got pregnant, I photographed her through that process. And then, of course, when Elinor was born, I started making pictures of her. And, originally, I viewed this as an extension of my practice because I've always made pictures of my life and what I'm going through. But I quickly realized through showing some of these images to people, either privately or in lectures, that they also filled a pretty significant gap in representations around queer families and queer parenting, especially for parents like me, who are butch or transmasculine. Those representations don't really exist. So, that's something I'm consciously thinking about in this work too.

MOSS: I think it's really interesting what you are saying, Jess, about how the passage of time is part of all of your work and also these life passages, and I'd love for Sedrick and Tom to comment on that too, the passage of time and life's passages.

HOLTON: I was just making photographs in Chinatown. I had no inkling that it would become, at this point, an eighteen-year adventure. I have a son who's eleven. I met the Lams before I was even married. Certainly the passage of time is very important in the Lams work.

HUCKABY: Like Tom said, there is the passage of time that happens. In my work, I question time, and I question existence in some ways. I think about people living at different periods of time and collapsing that time together, or I think about people who have passed away. In a number of the pictures the subjects wear memorial T-shirts, but there are also the sculptures. And it has to do with people who have died, after they stop existing and taking that existence and pressing it right up next to the person who is yet alive where we see them and collapsing that and bringing it together and questioning like, you know, in that sense, what is time.

UREÑA: Thank you. That's great. And all of this conversation about time is making me think of the pandemic where we started. When I came on, Jess and Sedrick, we were talking about where people are living different lives in a way in their different spaces right now with the pandemic. How has the pandemic really affected your notions of kinship, if at all?

DUGAN: For me, the pandemic has been hugely transformative for my work in a way that I didn't anticipate and that was frustrating at moments, but, ultimately, very productive. One of the biggest things was that the pandemic led to deeper existential thoughts about my own identity, about my family, about my relationships, about the broader community I'm part of, about what's important, and about the significance of time and how you spend it. I doubled down on choosing people and relationships that were important to me and choosing to spend time in a way that was deep and meaningful and validated my full self.

I made a lot of work at home. My practice was disrupted because I normally go to people's homes and photograph them, and I chose not to be inside with anyone for the first fifteen months. I made a lot of self-portraits. I made a lot of still lifes. I made work with Vanessa and Elinor. I made work with my mom and Chris. During the pandemic, my work took a much deeper emotional and psychological dive and became about something even more existential. And I think that's because I was thinking so much about our relationships being disrupted and what that means for us, both individually and collectively.

HOLTON: I agree 100 percent with Jess. You start thinking about how you want to spend your time, you want to spend your life, you know. It made me realize how much I value photography as an emotional outlet. I was in New York City in March and April 2020, which was pretty horrific, and I didn't see the Lams for two and a half months. That was the longest I had gone without seeing them in seventeen years. I usually see them every other week. When we felt comfortable seeing each other, they had no qualms about opening their doors to me. It was a little strange to be in a really small apartment that close to people. But it felt great.

UREÑA: Thanks. Sedrick?

HUCKABY: Yes, I agree. It made me just appreciate the people in my life more. You take so many things for granted going along. And you're doing life, you're pushing forward, but the pandemic hit the big pause button and made us all think about it a little more deeply. The thing that was so weird was that it caused you to think more deeply about family, etcetera, on the one hand. And then on the other hand, it disconnected you from people.

And I know, for me, it just confirmed a lot of things, but it made me appreciate the people who are in my life more. And then it also made me want to remember those who have played significant roles, those lives that we're all connected with.

CARAGOL: That is so beautiful what you have just said, Sedrick, in terms of remembering and finding a place in life, a space to honor relationships that have been. And I was thinking about this in relationship to all of your work, and, Tom, in relationship to the Lams, who I think you said had, unfortunately, divorced. When you are observing this organism of a living relationship for so long, how do you navigate the dynamic of that group as someone who's sort of an insider and an outsider at the same time?

HOLTON: I would have to say that their divorce was kind of slowly moving. It was tough to watch sometimes. There was a certain amount of tension in the air. And we had conversations about it. I knew what was happening. It changed the way I photographed, right? I started noticing things. They used to have three beds. If you're

familiar with the pictures, they used to have three beds put together like this and all five of them slept in it. And then they started creating like a bunk bed system. So they all started getting their own bunks, and, partially, that's because they're bigger kids. And you don't want to sleep next to your thirteen-year-old brother, and you want some privacy, but, also, I saw these as some barriers going up, emotional barriers, physical barriers. You know, it was a little heavier. And their pictures took a heavier tone too.

ICKES: It's so interesting because what I'm hearing…. I'm hearing a lot, but one thing is that photography became becomes a way to create kinship, so the medium itself is a force of creating kinship.

HOLTON: Well, what I always love about portraiture, and I think what Jess was mentioning also before, it's like you have an image that memorializes the photographer and the subjects, and maybe the subjects are strangers or loved ones. It's a shared experience for those few hours a day or whatever it is.

ICKES: I think it's important that you and Jess are also working over a time and series, so there's that durational aspect that allows those kinships to grow. The photograph has been theorized as kind of an instant, right, capturing a specific moment in time and that's it, but you both are working across time and stretching out what a photograph can be. And I think that certainly relates to how, you know, forms of kinship can then have that time and space to actually develop.

DUGAN: I love this idea of photographs creating kinship. For me, the process of photographing, the way that I work is so slow and collaborative, it functions as this way to carve out a special time and space with someone. I think of that especially with the pictures of me and my mom. There's a way in which this allows us to relate on a deeper level than we can at other times. Thinking about a project that takes place over a long period of time, and then thinking about the ways in which dynamics in all of these relationships shift and change, and then thinking about learning about myself through the act of photographing—both in the moment and in hindsight—is interesting for me.

And I understand the theory. And I understand that once you capture a moment, it won't happen again. But, for me, photography and the practice of creating portraits is such a life-affirming act, that I situate it differently. And I think it can also be life-affirming for a viewer in a different moment than when it was meaningful for me.

HUCKABY: Wow, and it's interesting. I'm thinking about how you all think about photo projects and how they incorporate time in them. And it makes me think about how a painting is never one moment. And there's this interesting thing of how we seek internally to be connected. And we seek that place that is kinship where we can identify with people and we're connected with people. And I found that even in the best cases, there's always a little bit of tension because, no matter what, there's the seeking of that connection, which feels really good, but then there's the opposite thing, that we're seeking this connection and that feels like

Kinfolk House, the collaborative project space that Sedrick and Letitia Huckaby opened in Fort Worth, Texas, in 2022. The home belonged to Hallie Beatrice Carpenter, Sedrick Huckaby's late grandmother, who was known to her friends as "Big Momma."

a great place, but we're ultimately disconnected. Nobody knows exactly what you think and what you feel like. And so you're seeking people who can identify. But, ultimately, that's some of what I deal with when I'm putting a sculpture against the painting or these images that seem like different people, but I'm collapsing them together because it's like, ultimately, there's a little bit of disconnect even in our connection. There's a little bit of nobody knows exactly

what's going on even when we can find people who can relate. And so that kind of push and pull, I think is important in art.

DUGAN: I love what you just said, Sedrick, and it makes me think about how the process of art making is a constant search that always fails a little bit. I was thinking about that in my work, really centering around this intersection of my own identity, or an individual identity, and a need to connect with others. And I think that's the most fundamental theme I can identify. But just as you were talking, I was thinking about how part of what compels me to create is that this connection is never full. It's never complete. And you're always on your own, even when you're in relationship. And that just seems like a core part of being an artist, especially when you work with other people.

ICKES: I'm thinking of that really special environment where you have the subject, the artist, but then the tool, the medium, whether it's the brush or the camera, and the brush as that third entity, right, inanimate, but something terribly important in this situation. And we're talking about how the camera or the brush might create kinships, not just represent them. Do your chosen mediums also afford you some kind of distance needed to actually do this?

DUGAN: My camera and my practice allow me to enter into emotional spaces with people that I wouldn't know how to access otherwise. When I'm giving talks, I sometimes joke that if I asked someone if I could come to their house and stare at them for an hour, they would say no, but

that's basically what my camera affords me. It allows me to go and look closely and carefully read someone's energy and be in this intimate space that I find it hard, if not impossible, to access without this tool, without this excuse to be there, and without a framework. We're trying to make a portrait together, and, therefore, we are engaging in a certain kind of relationship around this shared goal.

Your question about me within my family is interesting because I do think that the camera provides a closeness and a distance simultaneously. And I think it provides a framework through which to understand things that may be complicated. Sometimes, I'm aware of a certain family dynamic as I'm making a picture. And sometimes, I make a picture and then realize, oh, wow, there's tension here, or this is the dynamic that's playing out, or this is the question I'm asking right now. But, yes, I do think the camera is essential to me working out my own internal psychology and connecting with other people, whether they're my immediate family or people I just meet to make work with.

HUCKABY: I agree. I feel like it gives you the medium by which you can start to have discussions that would be hard to formulate with words or articulate in other ways. With these mediums, we can think and begin to engage and even understand. And I think that's one of the things that makes us artists or the type of artists that we are versus another type of artist.

HOLTON: I would have to agree with Sedrick and Jess, of course, and I never thought about it like this, Jess, but can

I come to your house and just stare at you for eighteen years? Now, the Lams just see me with my camera, and I'm not staring at them through the camera the whole time. It just sits there. But as a photographer, I'm paying attention to tension, I'm paying attention to tone in the room, obviously, the lighting at the moment, perhaps, and then where people sit and how they sit. And so the camera makes me much more observant. You know, without the camera there, I would just be watching TV, zoning out, but because it's there, I'm watching TV but also looking at the lighting over there, looking at where someone's sitting. Oh my god, they just put their foot up in the sunlight. That's pretty amazing.

Knowing the camera is sitting next to me, that changes the way my eyes observe. Because I'm so close to the Lams, I also talk about what's going on. And, oh my god, school is so hard, or I got in a fight with my boyfriend or my husband, my ex-husband is driving me crazy. So then that kind of informs you also a little bit.

MOSS: It's really interesting because this is making me think about the role of vulnerability in all of your work, in these situations where you were portraying your closest friends, these extended families, your family unit. I'd love to hear about how vulnerability works in your portrayals for this show because I do think it's key.

DUGAN: I think that's a really interesting question, Dorothy. I have asked my family to make very vulnerable photographs with me. I made a picture of Vanessa two days after Elinor was born in the hospital, and you can see the incision from her c-section. And I've made intimate pictures of my mom. One thing that's been important to me, especially in the work with Vanessa, is we have a policy that I can make anything I want, that she will always make pictures with me. And then there's a second review process about when and how we put it out into the world or if she feels comfortable with it being seen. And this is true with my mom, too.

I was actually kind of relieved when the show got delayed because the work still felt really fresh. I think something happens over time. A photograph that might feel very vulnerable when you make it feels different to you a year or two later, and you can see it in a different way.

This body of work requires that I negotiate questions of vulnerability and consent with my closest family, particularly around sharing intimate moments very publicly. And I realize that's a big ask.

UREÑA: Tom, I guess one question is whether the Lams look at your pictures before they're out in the world?

HOLTON: I tend to share with them everything I made. I send them the pictures. But I'm always nervous when a website comes out; the *New York Times* did something several years ago. And I'm always nervous that they're going to flip out and never open the door for me again. I think the mother is much more unaware of how, perhaps, the audience has grown for the Lams in terms of books and websites and whatnot. The father loves it. The daughter loves it. The father got stopped on the subway once. But I would agree that I think they're psychologically vulnerable, what

Jess was saying, because I know what's happening, they know what's happening.

UREÑA: Thank you. And, Sedrick?

HUCKABY: Yes, I guess, when you think about it, you know, there are the things that are easy to talk about. We can go on, and we can talk about those things. But it seems as though, as an artist, you're interested in processing things that go deeper than that because that speaks more deeply to our humanity, to who we are, to the things that are going on, like, up underneath the surface. As a child, I was introverted. And art was a way that I could just process. And I think now in terms of the vulnerable; it's you're drawn to talk about those deep things that touch and push and that you think about and that you deal with as a human being. It's like a moth to a flame in some ways because it's always…. I deal a lot with life and death. And, in general, hey, that's easy, you know, life and death. But when you start talking about particular people who die and why did they die, then it starts to get a little hard to deal with … that's a hard conversation. But it's one that you feel is important to address and discuss. And so you allow it into the work for that very reason.

UREÑA: Thank you, Sedrick, and thanks to all of you. We have one more question. And, of course, if you wanted to talk about something else, please let me know. How have the shifting political landscape and current social movements affected your practice?

DUGAN: I can start. And, Dorothy, I just thought of something else about your

vulnerability question, but it ties into this last answer actually. I've found that sharing my own vulnerabilities and identity with an audience through my art practice can be incredibly healing for them and also for me. And so there is this way in which making yourself vulnerable is an act of strength, and an act of self-care, and an act of connection, and an act of intimacy. And sharing my own vulnerabilities has become a pretty significant part of my work and my practice.

MOSS: Just one thing on that, Jess, it makes me think that we've asked you to be that way to take these very intimate experiences into the Smithsonian. It's not just any museum. It's in Washington, and it's very public. I just want to thank you and recognize your courage in doing this with us. I think it will translate to the visitors and give them courage and help people see themselves in new ways. And we're grateful for that.

DUGAN: Thank you, Dorothy. I'm honored to be part of this exhibition at such an important and public museum. Sharing personal images and telling personal stories can be incredibly powerful and meaningful to other people. Seeing yourself represented in the world around you is critical and can be validating of your identity. It can signal to you that you're part of a larger community and a larger experience. And that's something I think about in this work, too. Even though, in some ways, it's very specific and about my own relationships and family, I'm also aware that it offers a particular kind of representation in a very public place. And I'm aware of how that will affect the people who see it.

HUCKABY: One of the things that has happened to me as a result of this moment is I find myself pushing with a little more gravity on those social political issues, even to the extent where I would almost call it activism. We were really involved in doing a large street mural here and inspiring a number of murals in the area. We did a campaign of murals to get people to vote. And I think the final pushing at even getting the Kinfolk house open has to do something with that. And I worked on a piece and am currently working on a piece that deals with the one name that's on the record for Tarrant County's ... we have one name that went on record for being lynched in Tarrant County, the area where I live in Fort Worth. And there's just a push to be more active, be more engaging, and not be passive during this time. So that's the best I can say.

UREÑA: Thank you. Tom?

HOLTON: I have to say, you know, perhaps the role of photographers, artists, institutions, Smithsonian curators, if a viewer could see a body of work by any artist doing any kind of particular medium, and it opens up their understanding of the bigger human experience, that's a win, right?

In terms of what has been happening the last several years or couple years, I had a small exhibition of just four photographs in Chinatown, at a small gallery that's actually a window front, and it was literally around the corner from where Lams live. And we spoke about putting these pictures up in the neighborhood, which was full of tourists. Now, of course, Chinatown is changing greatly. The fact that there are galleries now where there used to be, you know, laundry shops, or whatever, or restaurants is just a changing reality in New York City. And so much of this Asian hate is happening at the same time and continues to happen. We felt it was important that the images were not behind the closed doors of the gallery, up the elevator. And if someone is walking down the street and takes a look at *The Lams of Ludlow Street* and realizes Ludlow Street is literally around the corner, they'll have a better understanding of how relatively normal they are, perhaps, or complicated. That changes the conversation about understanding the Asian American experience. I thought that was really important that we showed it in Chinatown, around the corner from where the Lams live. I wasn't at the space as much as the curator was. He was saying kids were coming ... twenty-year-old's were coming up to him and saying these look like my house, you know, and maybe it makes them realize that they're just as important as anyone else that's photographed. I think that's very important. So that's my small form of activism, I suppose.

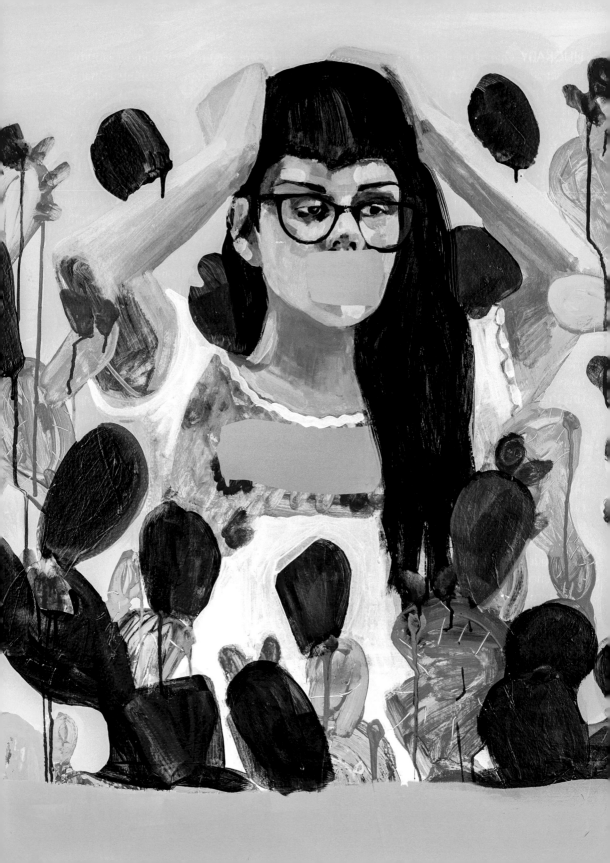

Kinship: In Conversation (Part II)

Ruth Leonela Buentello, Jessica Todd Harper, and Anna Tsouhlarakis

Interviewed by Robyn Asleson, Taína Caragol, Charlotte Ickes, and Leslie Ureña

This conversation was held via Zoom on November 10, 2021. The following transcript has been edited for length and clarity.

UREÑA: Why don't we get started with the first question we sent, which is, how does your notion of kinship shape your practice?

HARPER: So, I think, as is true of probably any of us, we're influenced by our upbringing, and my dad is an oncologist. And my mother helped found a hospice when she was in her early thirties because she had cancer in her twenties, so I grew up very much with a discussion of death and dying as part of the dinner table conversation.

Anyway, so there was that on one side, and then also my mother just came from a family that was very rich in storytelling. I think in my work, that's reflected by the intergenerational relationships and the inclusion of portraits of people who have already passed away, the sense that our lives have significance but are also

ephemeral. I think that's how the notion of kinship gets manifested in my particular work.

BUENTELLO: That was very powerful, Jessica. Thank you for sharing that. So, I was thinking about why kinship, and for me, a family was always what I knew, what I knew best and what I wanted to paint about. I got pushback about why I was painting family and whether my audience would get tired of seeing the same people over and over, and I didn't have that art history background to say, "Hey, so-and-so painted their mother over and over and over and over." I think what's different about my approach is that I am sharing intimate moments of my own family, and my family resonates with all kinds of families. I love painting them. I don't think I see enough of them in the art world, so representation is something that I'm also making sure that that happens, that I see families, working-class Chicano, Mexican immigrant families in art spaces.

TSOUHLARAKIS: When I think of kinship within my work, it feels like it's just another material that's in every piece that I do. It's just kind of a natural part of the mixture of every video, every sculpture, every installation I do, just as naturally as I would use any other material, because my process has always been about figuring out my place in the world in relationship to outside communities. Growing up between Kansas and New Mexico, I've always known I was Native American, and I've always known that I was Greek, but I know that that meant different things to different people And so, figuring out my experiences in relation to those interactions with people and how to translate those things as I got older into art pieces, it was natural for me to draw upon the stories, the oral traditions I heard from my dad and my grandmother and the stories I heard from the rest of my family members.

UREÑA: All three of you have touched on the storytelling, and it'd be great to hear a bit more about it.

HARPER: Let's think about that. I guess storytelling is something that presents others with an access point or entry to understanding the lived experience. Everybody navigates the world in relationship to others, even if it's not your family. Ideally, if art is done well, it can be a way of empathetically bringing other people into that understanding of how to make sense of life, how to create meaning and understanding from what can be a confusing, difficult experience.

TSOUHLARAKIS: I remember my grandmother, we were sitting on her bed, and she was older, and we were talking about Navajo names. And there was an instance where she was telling me stories about our different family members, and I was asking her what their names meant. And it occurred to me at that moment that when I think of a story, I think of it very linearly—or did so before that time—that it had a beginning, middle, and an end. And I realized that, depending on who you're talking to, it can have like multiple dimensions, specifically within Navajo, that there are different ways to describe things.

So, when I think of storytelling, that's what I think of within my work, is that it doesn't have to go like between the lines, that it doesn't have to go forward. It doesn't have to start from when we think we have to start. It can be that we can really define what the parameters are.

HARPER: That's really interesting about your experience with your grandmother and how sometimes things get lost in translation between languages, and knowing the native tongue is so important to fully understand the meaning. I don't know anything about Navajo, but I bet it's really different from English.

TSOUHLARAKIS: [Laughter] Yes.

BUENTELLO: I think for my work, storytelling is also in the materials that are being used. And I think about knowledge that's passed on from great-grandmothers, grandmothers that I've met, aunts and uncles, and the spaces they inhabit, specifically

their homes and the fabrics that are in their homes, the objects they keep in their homes, and so a lot of my work uses fabric as a way, kind of as a…. I feel like fabric is a character in my work, and it also creates a sense of place in my work, so it's placemaking. I think about how photography, for me, photography is the foundation of where I start to create an image and start to build that story. I feel like my paintings try to fill in the gaps of family photos that I spent hours and hours just trying to guess and think about each moment. The second that photo is taken, what is in that story that I don't know, that wasn't … what was behind that emotion or that day? So, I think, for me, storytelling is central, and I feel like it's the glue to my work, right?

ICKES: Anna, you certainly work across different media, but here, we talked about the centrality of performance to this work, this new work you're creating for us, and then Jessica, of course, your photographs and Ruth's paintings with other media involved as well. I'm curious why, like performance, photography, painting, what do those specific media do in terms of your relationship to kinship or how it helps create kinship?

TSOUHLARAKIS: For me, in terms of performance, specifically in a space like the National Portrait Gallery, I think my presence in the space is very unique, and it's temporary. It's ephemeral, and the interaction that people have with Natives in their daily life, especially in Washington, D.C., is rare if it ever happens throughout their entire lifetime.

And I think the medium of performance provides an immediacy that wouldn't otherwise be there, and to be present in their space, sharing this experience and this performance creates a connection that I think is so unique and just so strong immediately that for me, it makes so much sense that performance is that medium that's being used and that if I did anything else, there would still be some delineation between me and you instead of a we.

UREÑA: I don't know if Ruth or Jessica want to tackle next, but one of the things that, Charlotte, you brought up yesterday too was about how the chosen medium offers this potential for connectivity or for this disconnect, and you've just touched on that, Anna, in terms of the connection or the distancing in a way or how it can be incorporated into that. Ruth and Jessica?

HARPER: Roland Barthes already explained it very well, the beauty of photography. He describes that "punctum." It's a word he uses for a sort of prick that photography inherently has. It's painful because it's inherently describing something that no longer exists, so there's built-in nostalgia and a sort of memento mori quality to photography, and I've always thought that that dovetails very nicely with the themes in my work.

BUENTELLO: For my work, I feel that the kinship is seen in how I represent my family and the emotions that they experience with each other. The spaces they inhabit with each other is a form of kinship. I feel like the composites I create, they're memory and photography put together, and I think that

when people see them, they can get a sense of the space, the common space, whether it's physical or emotional.

UREÑA: Thank you for bringing up space. For Jessica, you work a lot in family homes, and Ruth, you're also depicting homes, and in your case, Anna, you're taking this to a different context, but how do your local contexts, whether your hometown or a region or home, influence how you approach to kinship in your work?

HARPER: Anna, you live in Washington, D.C.? Did I get that right?

TSOUHLARAKIS: I used to. We moved to Boulder in May of 2020, so I don't even really know what it's like to live here yet, so that's really strange. But I think, actually, when I was living in D.C. back in, I think it was in 2012, I started using social media as a way to interact with other Natives in different communities because I wanted to get people involved in an installation that I was doing. Because D.C. doesn't have a huge Native community, I was able to have my practice reach so many more people and kind of get them involved.

And I think that's something that I've continued to do, is to use social media to make those kinds of connections and, I think, create kinship within my work.

BUENTELLO: I was going to talk about San Antonio, the city I'm from, and how deeply rooted we are in family, family and intergenerational homes and how we live with each other. It has a history of Chicanos, Mexican American families here since before … for

millennia, and the work that I make really is specifically about San Antonio. I feel all of us relate that way with each other, with having our nieces and nephews living with each other. And that's still normal. It's not like, "Oh, you live with your mom," like, "Oh, my God." It's more of a respect, like we have a respect for our grandparents. We have a respect for teaching our young ones about life, so we all kind of give each other space, and we inform each other's lives. And that affects my work.

HARPER: Ruth, I didn't grow up with that, and I've always thought that was so appealing, the idea of living with so much family around. My relatives were scattered around the country. I convinced my sister and brother-in-law to move here outside of Philadelphia, and then I convinced my parents to come move here, and we all live in walking distance to each other. I really had this fantasy of this intergenerational living. It's such a benefit for the grandchildren, but especially during COVID, it was so nice to have my parents nearby, and we could still see them outdoors.

And I feel, for me at least, I don't feel like community is a given or just waiting for me out there. And I feel like that's something you always have to work at to reap the benefits of it all, having these rich relationships in life.

ASLESON: I'm curious about privacy. When you're dealing with family, it's your story, but it's also someone else's story, parents or children. Is that ever something that you struggle with or have to negotiate?

HARPER: I think, first of all, the people who look at my art are such a rarified audience. I certainly haven't experienced any widely popular fascination with my family. I'm not a Kardashian or something, and most people who encounter my work through a museum or a magazine aren't going to remember my name anyway, so I think that describes how the work interfaces with the world most of the time.

So far, I feel like the connections I've made with strangers have by and large been with people who are interested in saying that the work moved them. I also think about the fine art tradition; there are plenty of artists' family members who are in the canon. And I'm not sure that when you look at a relative of Whistler or Vermeer, anybody's thinking that that's a relative. They're thinking about the way the light hits the figure, the composition, and I trust that that's most of the time how my work will be remembered.

BUENTELLO: I think that's a really great way of putting it, Jessica. I've struggled with that a lot in my own work and how I portray my mother and my father, but I also see it as autobiographical. So, although they are the ones that are within the image, it says a lot about myself. I'm letting you into my lens.

TSOUHLARAKIS: I really like what Ruth said about this being like her lens. When I think about my work, that's what I'm always thinking about—trying to make sure that it stays within the realm of me because even though I use the community as a resource, I don't think of myself as a community artist.

And for this exhibition specifically, for my piece that I'm doing, I'm trying to be so respectful. It's been kind of a unique balance that I've never really faced before of having kind of my artistic vision of what I would like to do but also wanting to be so respectful to the women that have died or are missing and to give them the space they need within the exhibition and the piece. And so, that's a new way of working for me, which has been a good process so far.

ICKES: And, while we were talking about intimacy and closeness, both affectively and physically, there's also a way in which the role of artist is to create some kind of critical distance that's important in the creative process.

CARAGOL: Ruth, I think we had this conversation some months ago about how intense the proximity was before you moved, how close to and in a way, suffocating sometimes things can get with family, especially at that moment when we were all doing virtual school and all of that.

BUENTELLO: I lived with my parents in a small A-frame home. It was seven of us in the house, little ones, my brother, me, my baby, my parents, all the animals, so we got really close, but that also curtailed my practice. I wasn't able to create.

HARPER: I think that's such a common experience, particularly for women, and I'm really empathetic to what you're saying. When my kids first went on Zoom school and my husband started working at home, I felt like between navigating their school and teaching my classes and making sure that we had food and just trying to keep everyone happy, I just feel like as the mother—the role

is to just make sure that everybody else stays sane. I maybe made one or two pictures that whole time.

TSOUHLARAKIS: I have three little kids. They're seven, nine, and eleven, and it's so funny to me that when I think about when they were young and when they were born, when I was pregnant, I was still doing installations, going to shows. My middle daughter had been on fifteen flights by the time she was three months old because I was installing and going to openings and doing all this stuff. And then the pandemic was totally different, and even though you would think having a baby would shut life down in some ways, the pandemic just shut my brain down in terms of coming up with ideas. And I think it was having to worry about all of the other things that usually aren't at the fore-front of life are suddenly thrown in your face.

It really is because my work is about identity and social issues and those cultural interactions, that that's what I get fueled by. And when you don't have that going on, it's hard.

UREÑA: You probably have been watching the BLM protests and things through a screen, whether it's your phone or computer or on TV or however and the separation, and to go back to Taína's, the second part of the question, I guess, in terms of the social movements or what's happening in the world and how that influences your practice or even that sense of separation from it, how does that feed into the way you approach kinship and your practices as well, even if it's not the last year and a half when we have been separated from everything? Taína?

CARAGOL: Yes, and thinking about the work in the show but also beyond it, I think, for example, with Ruth's work, the work you did around zero-tolerance policy, for example, it's not precisely your family, although you did use them as models, and you sort of created composites. For you, Jessica, I think of the focus on children in your family, I don't know, in your family, maybe, but in your photographs, how present they are and how there seems to be so much about the inner world of a child that's there, although it's sort of mysterious too. And it's like we know it, and we don't know it at the same time, but to me as a mom, this time of the pandemic was, I mean, I could see the tension in my child. I could see how he was reacting to it, how he was scared about it at the beginning.

And so, how does that play into your work?

BUENTELLO: I want to say that my work finally felt validated because I felt like what was going on in the world was validating my family's experience and families like mine, our experiences as immigrants. So, it just felt really validating, even though there were horrific things going on; it was heartbreaking, but that also fueled a body of work that made me shift to not just documenting but also having a position and being more upfront about my position, where before, I felt like I was just making work about my identity, about my experience and narratives. But I've just felt more determined to say or to give voice to police assaults, police brutality, toward people who look like my family members, who I would see online, and I would say, "Oh, that looks like…." I'm

scared to death of this happening to my brother or scared to death of this happening to my mother, and so that's where that body of zero tolerance came from. It came from out of the fear of the Brown body and how it's a target.

UREÑA: Thanks for sharing. Anna, you brought it up a bit already, but your topic is obviously very focused on, your performance itself is very focused on this social movement.

TSOUHLARAKIS: I think this is the first time I've ever so pointedly focused on a specific social movement.

And usually, I focus more on experiences and interactions, and I think at least I try to be a lot more subtle with the way that I'm dealing with different social issues because I feel like specifically within the history of Native art, that there were a couple of decades where the art was really seen as kind of like angry Indians yelling around and protesting, which took us through the seventies and eighties, and so how do we keep that going or kind of continue that energy of voicing things but, I don't want to say more palatable, but in a way, that doesn't shut down the conversation? And I think that's what so many artists try to do within their work, to point out and to bring up these issues in a way that people feel as though they can actually enter the conversation.

HARPER: I think both of those are really thoughtful responses to what has been a very complicated last couple years with a lot of material to talk about. I was thinking about your questions in advance. I was reading excerpts from an interview with George Steiner, who was a Franco-American literary critic. He recalls one of his most powerful memories when he was about six years old. He's in Paris, and he's witnessing what turns into this very anti-Semitic march down the boulevard. And he sees it out from his balcony, and his mother draws the curtains to block it out, and his father brings him back out to the balcony and says, "This is called history, and you must never be afraid." And I feel like many of us have experienced fear in the last couple years for, pick your topic, whether it be politics or COVID or various social issues, trying to navigate them with your children. There's been a lot to be afraid of, but I feel like that quote is a powerful reminder that we're called to engage in the world.

UREÑA: Thank you.

Artists' Biographies

Njideka Akunyili Crosby

born 1983, Enugu, Nigeria
based in Los Angeles, California

Njideka Akunyili Crosby draws on art historical, political, and personal references to make densely layered representational compositions, whose intricate surfaces conjure the complexity of contemporary diasporic experience. She has exhibited at venues around the world, including Musée d'Art Moderne de Paris; Haus der Kunst, Munich; the National Portrait Gallery, London; Museum of Contemporary Art Chicago; the Whitney Museum of American Art, New York; Statens Museum for Kunst Copenhagen; the Metropolitan Museum of Art, New York; the Hammer Museum, Los Angeles; and the Studio Museum in Harlem. In 2019, her work was included in *May You Live in Interesting Times*, the central exhibition of the 58th Venice Biennale. Akunyili Crosby received a MacArthur Fellowship in 2017.

Ruth Leonela Buentello

born 1984, San Antonio, Texas
based in San Antonio, Texas

Ruth Leonela Buentello's practice is rooted in painting, but she incorporates other media into her work and is often involved with community arts and collaborative installations. She recently completed *Entre Fronteras Memory Migration Maps* (2021), a site-specific permanent public art installation within the City Hall of San Antonio. The project, like many of Buentello's portraits, centers on rendering Xicana/o/x working-class communities more visible. Buentello has exhibited at the Meadows Museum of Art, San Antonio; the Mildred Lane Kemper Art Museum, St. Louis, and the National Museum of Mexican Art, Chicago. She was a finalist in the National Portrait Gallery's fifth Outwin Boochever Portrait Competition (2019).

Jess T. Dugan

born 1986, Biloxi, Mississippi
based in St. Louis, Missouri

Jess T. Dugan is an artist who explores issues of identity through photographic portraiture. Their work has been widely exhibited and is in the permanent collections of over forty museums throughout the United States. Their monographs include *Look at me like you love me* (MACK, 2022), *To Survive on This Shore: Photographs and Interviews with Transgender and Gender Nonconforming Older Adults* (Kehrer Verlag, 2018), and *Every Breath We Drew* (Daylight Books, 2015). Dugan has received a Pollock-Krasner Foundation Grant and an ICP Infinity Award and was selected by the Obama White House as an LGBT Artist Champion of Change.

LaToya Ruby Frazier

born 1982, Braddock, Pennsylvania
based in Chicago, Illinois

LaToya Ruby Frazier's artistic practice centers on the nexus of promoting social justice and cultural change while commenting on the American experience. Spanning a wide range of media, her interconnected bodies of work use collaborative storytelling to address topics related to industrialism, the environment, and human rights. Frazier, who received a MacArthur Fellowship in 2015, is an associate professor of photography at the School of the Art Institute of Chicago. Her work has been the subject of numerous solo exhibitions in the United States and Europe, and she has published several monographs. *Flint Is Family In Three Acts* (Steidl, 2022) is her latest book.

Jessica Todd Harper

born 1975, Albany, New York
based in Philadelphia, Pennsylvania

Photographer Jessica Todd Harper uses portraiture to explore the subtle tensions within daily family interactions and the complexity of human relationships. Her work is grounded in the art historical tradition, but with a psychological undercurrent that marks its modernity. A silver medalist in the Prix de la Photographie in Paris (2014), she was an Outwin Boochever Portrait Competition prizewinner (2016) and was selected that same year for the Taylor Wessing Photographic Portrait Prize at the National Portrait Gallery in London. Harper has published two prize-winning books of photography, *Interior Exposure* (Damiani, 2008) and *The Home Stage* (Damiani, 2014).

Thomas Holton

born 1969, Guatemala City, Guatemala
based in New York City

Thomas Holton received his MFA from the School of Visual Arts in 2005, and his work has been exhibited widely at venues such as the New York Public Library, the Museum of the City of New York, the China-Lishui International Photography Festival, and Sasha Wolf Gallery. *The Lams of Ludlow Street* was featured once in *Aperture* (2007), three times in the *New York Times* (2008, 2012, 2016), and in numerous other magazines, newspapers, and websites. Kehrer Verlag published his first monograph, *The Lams of Ludlow Street*, in 2016. He lives in Brooklyn, New York, with his wife and family.

Sedrick Huckaby

born 1975, Fort Worth, Texas
based in Fort Worth, Texas

After earning an MFA from Yale University and studying art abroad, Sedrick Huckaby returned home to Fort Worth in the early 2000s. Since then, he has focused on making portraits that express universal themes of faith, family, community, and heritage. Painting is Huckaby's primary medium, but his work frequently blurs the lines between painting, sculpture, and installation. He has twice been a finalist in the Outwin Boochever Portrait Competition (2016 and 2019) and has received a Guggenheim Fellowship and Fulbright U.S. Scholar Award, among other accolades. Huckaby's work has been collected by major museums, notably the Art Institute of Chicago, the Whitney Museum of American Art, New York, and the San Francisco Museum of Modern Art.

Anna Tsouhlarakis

born 1977, Lawrence, Kansas
based in Boulder, Colorado

Anna Tsouhlarakis received her MFA from Yale University and has participated in various art residencies, including those at the Skowhegan School of Painting and Sculpture and Yaddo. She has been in national and international exhibitions at venues such as Rush Arts in New York, the Art Gallery of Ontario in Toronto, and the Smithsonian's National Museum of the American Indian. Recent awards include fellowships from the Harpo Foundation, the DC Commission on the Arts and Humanities, and a 2021 Creative Capital Award. Tsouhlarakis is Greek and Creek and is an enrolled citizen of the Navajo Nation.

Exhibition Checklist

Njideka Akunyili Crosby

Nkem, 2012
Acrylic and transfers
on paper
192.9 × 129.5 cm
(75 $^{15}/_{16}$ × 51 in.)
Rubell Museum
see p. 27

Thelma Golden, 2013
Acrylic, transfers, and
colored pencil on paper
132.1 × 109.2 cm
(52 × 43 in.)
National Portrait Gallery,
Smithsonian Institution
see p. 17

**"The Beautyful Ones"
Series #3**, 2014
Acrylic, colored pencil,
collage, charcoal, and
transfers on paper
155.6 × 106.7 cm
(61 ¼ × 42 in.)
Collection of Caren
Golden and Peter
Herzberg
see p. 30

**"The Beautyful Ones"
Series #2a**, 2016
Acrylic, transfers, and
colored pencil on paper
155.6 × 106.7 cm
(61 ¼ × 42 in.)
Collection of
Charles Gaines
see p. 31

Ruth Leonela Buentello

**Under the Mexican
Colchas**, 2012
Acrylic on canvases
with fabric
121.9 × 152.4 cm
(48 × 60 in.),
Courtesy of the artist
see p. 15

Gamer Niñas, 2019
Acrylic on canvas
with fabric
152.4 × 203.2 cm
(60 × 80 in.)
Courtesy of the artist
see p. 37

**Entender de dónde
nace tu manera de ser**
(Understanding where
your selfhood
comes from), 2020
Acrylic on canvas
with fabric
213.4 × 152.4 cm
(84 × 60 in.)
Courtesy of the artist
see p. 36

Nopalera, 2020
Acrylic and latex on panel
101.6 × 91.4 cm
(40 × 36 in.)
Courtesy of the artist
see p. 35

Jess T. Dugan

All works are from the
series "Family Pictures,"
2012–ongoing

**Mom holding Elinor
(one month)**, 2018
Inkjet print
101.6 × 76.2 cm
(40 × 30 in.)
Courtesy of the artist
see p. 44

**Self-portrait with
Elinor (screen)**, 2018
Inkjet print
101.6 × 76.2 cm
(40 × 30 in.)
Courtesy of the artist
see p. 41

**Vanessa and Elinor
in the shower,
Provincetown, MA**, 2019
Inkjet print
101.6 × 76.2 cm
(40 × 30 in.)
Courtesy of the artist
see p. 45

**Early morning light,
Boston**, 2020
Inkjet print
76.2 × 101.6 cm
(30 × 40 in.)
Courtesy of the artist
see p. 43

Elinor on the bed, 2020
Inkjet print
76.2 × 101.6 cm
(30 × 40 in.)
Courtesy of the artist
see p. 46

**Self-portrait with
mom (bed)**, 2020
Inkjet print
76.2 × 101.6 cm
(30 × 40 in.)
Courtesy of the artist
see p. 14

**Self-portrait with
Vanessa**, 2020
Inkjet print
76.2 × 101.6 cm
(30 × 40 in.)
Courtesy of the artist
see p. 47

LaToya Ruby Frazier

All works are from the series "Flint Is Family In Three Acts," 2016–21

Flint Is Family, 2016
Video, color with sound, 11:50 min.
Courtesy of the artist and Gladstone Gallery
see pp. 52–53

Shea Brushing Zion's Teeth with Bottled Water in Her Bathroom, Flint, Michigan, 2016–17
Gelatin silver print
61 × 50.8 cm (24 × 20 in.)
Collection of Priscilla Vail Caldwell
see p. 19

Shea Cobb with Her Mother, Ms. Reneé, and Her Daughter, Zion, at Nephratiti's Wedding Reception, Standing Outside the Social Network Banquet Hall, Flint, Michigan, 2016–17
Gelatin silver print
101.6 × 76.2 cm
(40 × 30 in.)
Courtesy of the artist and Gladstone Gallery
see p. 54

The Flint Water Treatment Plant, Flint, Michigan, 2016–17
Gelatin silver print
50.8 × 61 cm (20 × 24 in.)
Courtesy of the artist and Gladstone Gallery
see p. 55

Self-Portrait with Shea and Her Daughter, Zion, in the Bedroom Mirror, Newton, Mississippi, 2017–19
Gelatin silver print
76.2 × 101.6 cm
(30 × 40 in.)
Courtesy of the artist and Gladstone Gallery
see p. 51

Shea and Her Daughter, Zion, Sipping Water from Their Freshwater Spring, Newton, Mississippi, 2017–19
Gelatin silver print
61 × 50.8 cm (24 × 20 in.)
Courtesy of the artist and Gladstone Gallery
see p. 56

Shea and Her Father, Mr. Smiley, in His Living Room, Newton, Mississippi, 2017–19
Gelatin silver print
61 × 50.8 cm (24 × 20 in.)
Courtesy of the artist and Gladstone Gallery
see p. 57

Jessica Todd Harper

Becky with Papa, 2007
Inkjet print
81.3 × 101.6 cm
(32 × 40 in.)
Courtesy of the artist
see p. 63

Self-Portrait with Marshall, 2008
Inkjet print
81.3 × 101.6 cm
(32 × 40 in.)
Courtesy of the artist
see p. 64

Marshall (Yellow Ball), 2011
Inkjet print
81.3 × 81.3 cm
(32 × 32 in.)
Courtesy of the artist
see p. 12

Marshall with Family and the World, 2013
Inkjet print
67.6 × 101.6 cm
(25 ⅝ × 40 in.)
Courtesy of the artist
see p. 65

The Dead Bird, 2018
Inkjet print
67.6 × 101.6 cm
(26 ⅝ × 40 in.)
Courtesy of the artist
see p. 61

Self-Portrait with Catherine and Dolls, 2018
Inkjet print
73.7 × 101.6 cm
(29 × 40 in.)
Courtesy of the artist
see p. 66

Comics, 2020
Inkjet print
67.6 × 101.6 cm
(26 ⅝ × 40 in.)
Courtesy of the artist
see p. 67

Thomas Holton

All works are from the series "The Lams of Ludlow Street," 2003–ongoing

Passport Photos, 2003
Inkjet print
33 × 50.8 cm (13 × 20 in.)
Courtesy of the artist
see p. 72

Bath Time, 2004
Inkjet print
33 × 50.8 cm (13 × 20 in.)
Courtesy of the artist
see p. 73

Family Portrait, 2004
Inkjet print
33 × 50.8 cm (13 × 20 in.)
Courtesy of the artist
see p. 18

Conversation, 2005
Inkjet print
33 × 50.8 cm (13 × 20 in.)
Courtesy of the artist
see p. 74

Bored, 2011
Inkjet print
33 × 50.8 cm (13 × 20 in.)
Courtesy of the artist
see p. 75

Dinner for Seven, 2011
Inkjet print
33 × 50.8 cm (13 × 20 in.)
Courtesy of the artist
see p. 76

Online at a Friend's, 2011
Inkjet print
33 × 50.8 cm (13 × 20 in.)
Courtesy of the artist
see p. 77

College Orientation, 2014
Inkjet print
33 × 50.8 cm (13 × 20 in.)
Courtesy of the artist
see p. 78

Steven's Walk-in Closet, 2014
Inkjet print
33 × 50.8 cm (13 × 20 in.)
Courtesy of the artist
see p. 71

Watching Black Mirror, 2019
Inkjet print
33 × 50.8 cm (13 × 20 in.)
Courtesy of the artist
see p. 79

Zooming with Cindy, 2021
Inkjet print
33 × 50.8 cm (13 × 20 in.)
Courtesy of the artist
see p. 79

Sedrick Huckaby

Gone but Not Forgotten: Sha Sha, 2017
Oil on canvas on panel
182.9 × 91.4 cm
(72 × 36 in.)
Jesuit Dallas Museum,
Dallas, Texas
see p. 20

AMEN, 2020
Paintings: oil on
canvas on panel,
each 188 × 121.9 cm
(74 × 48 in.), framed
Sculpture: newspaper
papier-mâché on wood
platform, 157.5 × 30.5 ×
40.6 cm (62 × 12 × 16 in.)
Rennie Collection,
Vancouver
see p. 85

Connection, 2020
Painting: oil on
canvas on panel,
182.9 × 121.9 cm
(72 × 48 in.)
Sculpture: newspaper
papier-mâché, desk
chair, and cardboard
on wood platform,
119.4 × 71.1 × 125.7 cm
(47 × 28 × 49 ½ in.)
Courtesy of the artist
and Talley Dunn Gallery,
Dallas, Texas
see pp. 82–83

Anna Tsouhlarakis

Portrait of an Indigenous Womxn [Removed]
Conceptualized in 2021,
to be performed in 2023
Performance
Courtesy of the artist
see p. 21 and p. 89

Acknowledgments

Kinship would not have been possible without the dedication that the artists brought to the project. Our deepest thanks go to Njideka Akunyili Crosby, Ruth Leonella Buentello, Jess T. Dugan, LaToya Ruby Frazier, Jessica Todd Harper, Thomas Holton, Sedrick Huckaby, and Anna Tsouhlarakis. And we are extremely grateful to the lenders of the exhibition: Priscilla Vail Caldwell, Charles Gaines, Caren Golden and Peter Herzberg, Talley Dunn Gallery, Gladstone Gallery, the Rennie Collection, the Jesuit Dallas Museum, the Rubell Museum, David Zwirner Gallery, Victoria Miro Gallery, and Philip Martin Gallery. These individuals, galleries, and museums generously agreed to part with key artworks for the duration of the exhibition. We also wish to thank Rick Wester Fine Art, Emily Bates, Lilly Bajraktari, Anna Fisher, Erin Manns, Britta Nelson, Laura Randall, Chris Rawson, Hanna Schouwink, and Sam Yehros for their crucial help with this endeavor.

As curators, we have been incredibly fortunate to discuss this project with colleagues across the Smithsonian. At the National Museum of the American Indian, we had insightful conversations with Bethany Bentley, Ashley Minner, and David Penney. Craig Blackwell and Lauryn Guttenplan, in the office of general counsel, offered important guidance. We also appreciate the advice we received from Kathleen Ash-Milby, curator of Native American art, at the Portland Art Museum

At the National Portrait Gallery, we are grateful to have had the steadfast support of our director, Kim Sajet, and our director of curatorial affairs, Rhea Combs. Chief curator emeritus, Brandon Brame Fortune, and former senior historian, Gwendolyn DuBois Shaw, provided valuable insight and encouragement.

Dominique DelGiudice, the museum's exhibitions program specialist; along with Marlene Harrison, interim head of exhibitions; Beth Isaacson, former project manager; and Claire Kelly, former head of exhibitions; managed the details of the project with grace and aplomb. In the office of the registrar, Sophia Brocenos, Todd Gardner, Dale Hunt, Wayne Long, Marissa Olivas, and Jennifer Wodzianski safeguarded the artworks and handled the requisite shipments. The design and production team, Michael Baltzer, Peter Crellin, Sally Kim, Adam Ressa, Laura Thornton, Tibor Waldner, and Anne Wilsey, developed a beautiful and sensitive installation. They were joined by Alexander Cooper, Mark Gulezian, Grant Lazer, and Luke Moses in the office of exhibition technology. Im Chan, in the conservation department,

devoted time to caring for the works on paper.

The museum's audience engagement team found innovative ways to make the exhibition accessible to both in-person and online visitors. We especially thank Erin Beasley, Kaia Black, Ashleigh Coren, Beth Evans, Vanessa Jones, Rebecca Kasemeyer, Geri Provost Lyons, Deb Sisum, and Briana Zavadil White.

In the office of publications, Rhys Conlon, along with Sarah McGavran, worked closely with us to edit the book's manuscript and develop a beautiful publication. At Hirmer Publishers, Rainer Arnold, Sophie Friederich, Bram Opstelten, and Elisabeth Rochau-Shalem demonstrated unwavering professionalism and creativity. María Eugenia Hidalgo crafted beautiful Spanish-language translations of the in-gallery materials, allowing us to broaden the exhibition's reach.

Concetta Duncan and Gabrielle Obusek, both in the museum's office of communications, have ensured that *Kinship* reaches as wide of an audience as possible.

We are deeply grateful to Sara Mazzoleni and Kristy Snaman, in special events, for planning such a wonderful opening celebration. Our thanks also go to Brandon Pinzini, formerly in the office of the director. In the office of advancement, we are grateful to Megan Beck, Raven Bradburn, Lindsay Gabryszak, Matthew Gray, and Usha Subramanian for their fundraising acumen. In the finance department, we are indebted to Jolene Johnson, Victor Onireti, Rich Reichley, Arthur Self, and Dina Wilkins for their critical help.

We are lucky to have worked with a number of remarkable interns over the course of this project. Elizabeth Fischer, Elizabeth Ho-Sing-Loy, Megan True, and Sara Sims Wilbanks conducted research for the exhibition, while Kathryn Prinkey saw to it that research findings, bibliographies, and object lists remained up to date. Matthew Phillips and Frances Pool-Crane assisted with copyediting.

The *Kinship* team has undergone significant changes since the exhibition originated in 2018. Some colleagues have left the museum, while others have only recently arrived. Through the years, the museum's curators have maintained meaningful connections with former staff. We are grateful for the institutional memory shared across the generations and thank Carolyn K. Carr and Brandon Brame Fortune for reviewing the "Portraiture Now" history.

In our personal lives, children have been born, and loved ones have been lost. While these pivotal events would have realigned our relationships under any circumstance, set against the background of the pandemic, these life changes took on new meanings. Today, we share a kinship of another sort. Our curatorial approach has been inflected by sustained study and discussions that center on how works in this exhibition—and the "Portraiture Now" series, in general—speak to the National Portrait Gallery's broader mission and its commitment to becoming more inclusive. We hope visitors to the exhibition and readers of this catalogue will feel a sense of belonging and find kinship as we face the future alongside one another.

The curatorial team dedicates this book to our kin, near and far, who have informed our approach to this project. Thank you.

Further Reading

Berry, Ian, and Steven Matijcio, eds. *Njideka Akunyili Crosby: Predecessors.* Saratoga Springs, NY: Frances Young Tang Teaching Museum and Art Gallery at Skidmore College, 2019. Exhibition catalogue.

Brutvan, Cheryl. *Njideka Akunyili Crosby: I Refuse to Be Invisible.* West Palm Beach, FL: Norton Museum of Art, 2016. Exhibition catalogue.

Buentello, Ruth Leonela. "In the Studio: Ruth Leonela Buentello." Joan Mitchell Foundation. October 30, 2019, joanmitchellfoundation.org.

Caligor, Livia. "Q&A with Photographer Thomas Holton: The Artist Behind 'The Lams of Ludlow Street.'" *ClichéMag,* July 3, 2021.

Dedieu, Jean-Philippe. "Njideka Akunyili Crosby's Intimate Universes." *The New Yorker,* November 5, 2015.

Dugan, Jess T. *Look at Me Like You Love Me.* London: MACK, 2022.

Dugan, Jess T., and Vanessa Fabbre. *To Survive on This Shore: Photographs and Interviews with Transgender and Gender Nonconforming Older Adults.* Heidelberg: Kehrer, 2018.

Enwezor, Okwui, ed. *Grief and Grievance: Art and Mourning in America.* London: Phaidon; New York: New Museum, 2021. Exhibition catalogue.

Frazier, LaToya Ruby, Shea S. Cobb, Amber N. Hasan, Douglas R. Smiley, Michal Raz-Russo, Leigh Raiford, and Peter W. Kunhardt Jr. *Flint Is Family In Three Acts.* Edited by Michal Raz-Russo. Göttingen: Steidl; Pleasantville, NY: The Gordon Parks Foundation, 2022.

Frazier, LaToya Ruby, Dennis C. Dickerson, Laura Wexler, Dawoud Bey, and Lesley A. Martin. *The Notion of Family.* New York: Aperture, 2016.

Frazier, LaToya Ruby, Karsten Lund, and Solveig Øvstebø. *The Last Cruze.* Chicago: The Renaissance Society at the University of Chicago, 2020.

Harper, Jessica Todd. *The Home Stage.* Bologna: Damiani, 2014.

Harper, Jessica Todd. *Interior Exposure.* Bologna: Damiani, 2008.

Holton, Thomas, Charles Traub, and Bonnie Yochelson. *The Lams of Ludlow Street.* Heidelberg: Kehrer, 2016 [2015].

Hoska, Dakota, and Polly Nordstrand. *Anna Tsouhlarakis: To Bind or To Burn.* Edited by Katja Rivera and Blair Huff. Colorado Springs: Colorado Springs Fine Arts Center at Colorado College, 2022 (forthcoming).

Huckaby, Sedrick. "*Estuary* Walkthrough." Philip Martin Gallery. April 21, 2021, philipmartingallery.com.

Huckaby, Sedrick, and Carter Foster. "Blanton Curated Conversations." Blanton Museum of Art. October 8, 2021, youtube.com.

Lescaze, Zoë. "LaToya Ruby Frazier, American Witness," *New York Times,* March 1, 2021.

Liebert, Emily, and Nadiah Rivera Fellah, eds. *Picturing Motherhood Now.* Cleveland: Cleveland Museum of Art; New Haven, CT: Yale University Press, 2021. Exhibition catalogue.

Mitter, Siddhartha. *Njideka Akunyili Crosby: "The Beautyful Ones."* Venice: Victoria Miro, 2019.

Schneider, Anna, ed. *Interiorities: Njideka Akunyili Crosby, Leonor Antunes, Henrike Naumann, Adriana Varejão.* New York and Munich: Prestel; Munich: Haus der Kunst, 2020. Exhibition catalogue.

White, Simone. "Skin, Or Surface: Njideka Akunyili Crosby." *Frieze,* no. 194 (April 2018): 96–101.

Image Credits

Credits

Artists' Copyrights

Photographic Credits

Imprint

Published to accompany the exhibition *Kinship*.
National Portrait Gallery,
Smithsonian Institution,
Washington, D.C.
October 28, 2022—January 7, 2024

National Portrait Gallery
8th and G Streets NW
Washington, D.C. 20001

Hirmer Publishers
Bayerstrasse 57—59
80335 Munich
Germany

Head of Publications: Rhys Conlon

Editor: Sarah McGavran

Senior Editor, Hirmer Publishers: Elisabeth Rochau-Shalem

Project Manager, Hirmer Publishers: Rainer Arnold

Copyediting and proofreading: Bram Opstelten

Design and visual editing, Hirmer Publishers: Sophie Friederich

Pre-press: Reproline Mediateam, Unterföhring

Fonts: Freight Text, Museo sans

Paper: GardaMatt Art, 150 g/sqm

Printing and binding: DZA Druckerei zu Altenburg

Printed in Germany

Bibliographic information published
by the Deutsche Nationalbibliothek
The Deutsche Nationalbibliothek lists this
publication in the Deutsche Nationalbibliografie;
detailed bibliographic data is available on the
Internet at http://www.dnb.de

ISBN 978-3-7774-3977-8

www.hirmerpublishers.com

National Portrait Gallery | Smithsonian